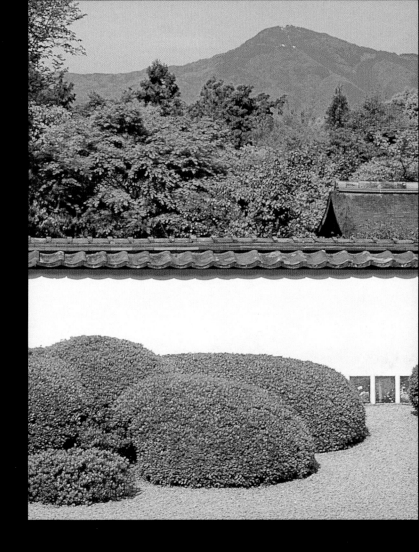

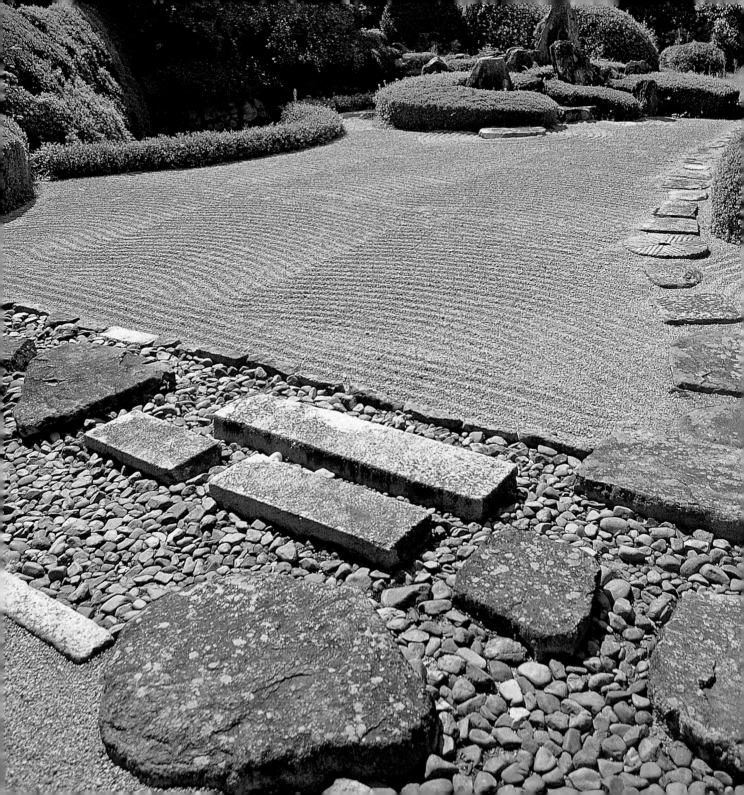

JAPANESE STONE GARDENS

ORIGINS · MEANING · FORM

Stephen Mansfield

Foreword by Donald Richie

TUTTLE PUBLISHING
Tokyo · Rutland, Vermont · Singapore

Published by Tuttle Publishing, an imprint of Periplus Editions (HK) Ltd, with editorial offices at 364 Innovation Drive, North Clarendon, Vermont 05759 USA and 61 Tai Seng Avenue #02-12, Singapore 534167.

Photos © 2009 Stephen Mansfield
Text © 2009 Stephen Mansfield

ISBN 978-4-8053-1056-4

Distributed by:
North America, Latin America & Europe
Tuttle Publishing
364 Innovation Drive, North Clarendon, VT 05759-9436, USA
Tel: 1 (802) 773-8930; Fax: 1 (802) 773-6993
info@tuttlepublishing.com
www.tuttlepublishing.com

Japan
Tuttle Publishing
Yaekari Building, 3rd Floor
5-4-12 Osaki, Shinagawa-ku, Tokyo 141 0032, Japan
Tel: (81) 3 5437-0171; Fax: (81) 3 5437-0755
tuttle-sales@gol.com

Asia Pacific
Berkeley Books Pte Ltd
61 Tai Seng Avenue #02-12, Singapore 534167
Tel: (65) 6280-1330; Fax: (65) 6280-6290
inquiries@periplus.com.sg
www.periplus.com

Printed in Singapore

14 13 12 11 10
8 7 6 5 4 3 2

TUTTLE PUBLISHING® is a registered trademark of Tuttle Publishing, a division of Periplus Editions (HK) Ltd.

FRONT ENDPAPER Stone pillars from a former temple outhouse are used to create a side garden at Tofuku-ji Temple (page 108).

BACK ENDPAPER Flat stones at the edge of gravel at Raikyu-ji Temple (page 128) were later additions to the garden.

PAGE 1 The perfect *shakkei* or "borrowed view" at Shoden-ji Temple (page120).

PAGE 2 Stepping stones at Raikyu-ji (page 128) lead to a cluster of rocks commonly interpreted as representing either Mount Sumisen or a crane island.

RIGHT Large granite rocks at a pavilion beside Kongobu-ji, a Shingon sect temple on Mount Koya, a sacred Buddhist complex in Wakayama Prefecture.

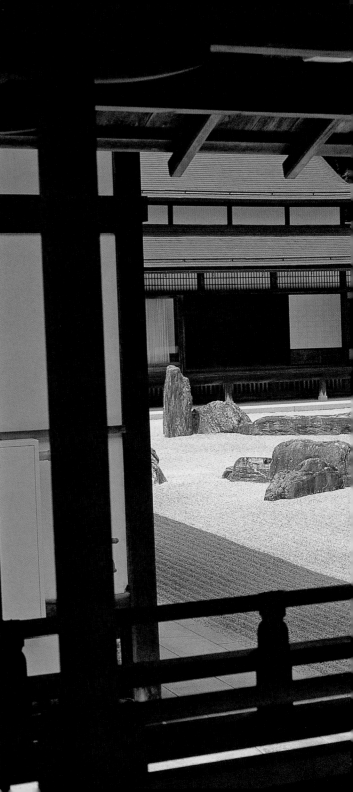

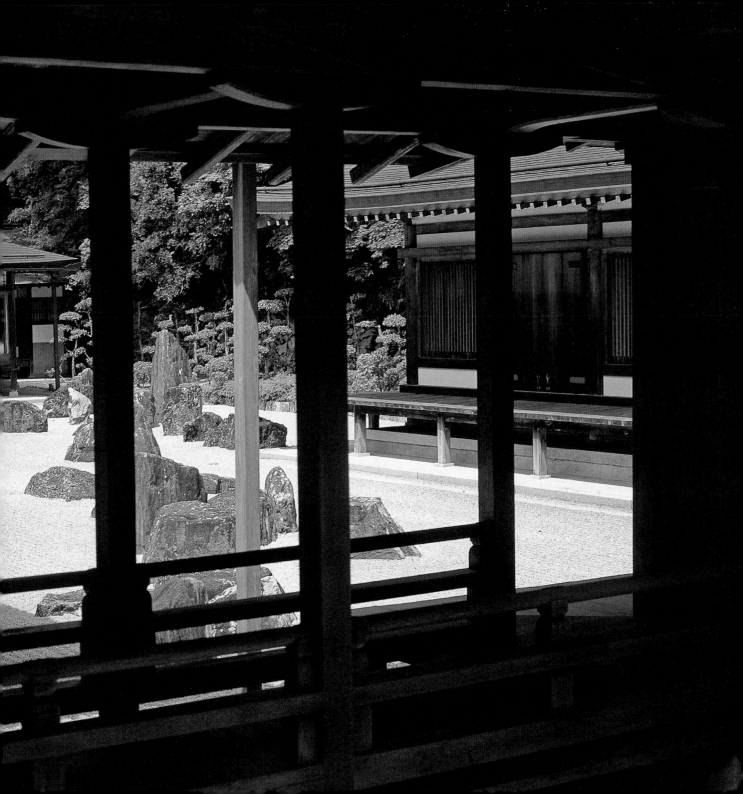

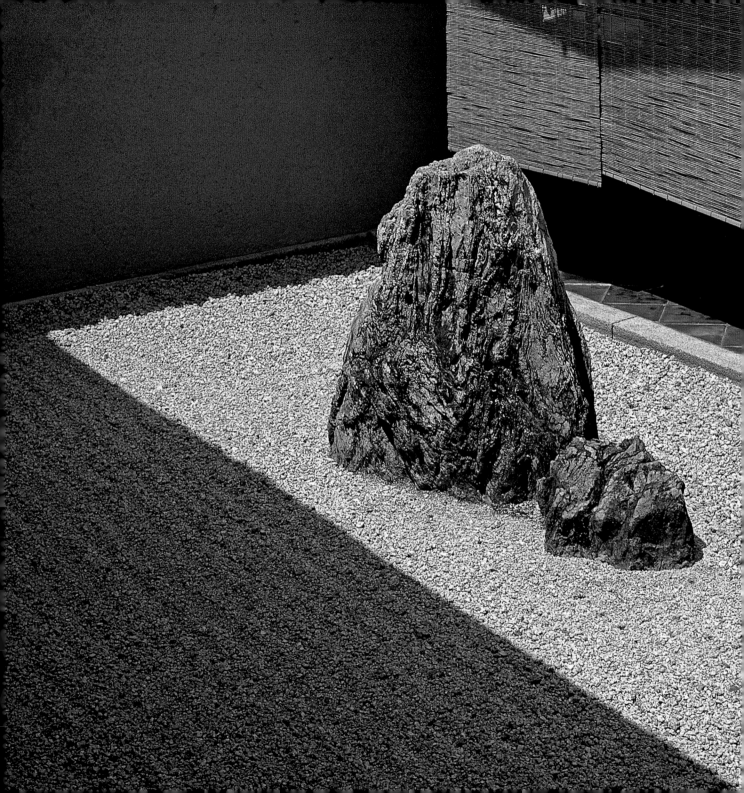

CONTENTS

FOREWORD

PAGES 6–7 Two of three rocks in a stone triad, named the Chukai or "middle sea," in the garden section of Daisen-in, a sub-temple of Daitoku-ji in northern Kyoto.

ABOVE The pipe, mat and teapot in this illustration demonstrate that private gardens were not always used strictly for meditation practices.

When Isaac Watts, the well-known eighteenth-century hymn writer, wanted to suggest an ideal site for meditation, he chose the image of a garden:

We are a garden walled around,
Chosen and made peculiar ground;
A little spot enclosed by grace,
Out of the world's wide wilderness.

Here, within this natural corner, was a place for us to contemplate, a garden within us, burgeoning but quiet, alert, alive but still. It was, as Francis Bacon had written a century earlier, indeed of divine origins: "God Almighty first planted a garden...."

This confluence – nature and ourselves, deities and mankind – is one which occurs time and again as we experience a constant need for more than what our meager civilizations can afford us. Perhaps that is why we believe that God Almighty created this quiet utopia. It is because we think that we ourselves could construct only a matching dystopia.

"God, the first garden made and, the first city, Cain," wrote the seventeenth-century poet Abraham Cowley in his attempt to explain both our needs and our limitations. The imperatives and constraints are very real, and they are basic. God's gardening goes on all over the world, and we, children of Cain, in the midst of the world's wide wilderness, go on making messes.

One of the most beautiful expressions of this need and one of the only indications of its solution is found in the Asian attitude toward meditation – as seen in the subject of this book: the stone gardens of Japan.

Gardens of stone – these we might see as contradictions in terms. Such a description would seem to deny the very qualities we assign the garden – something supposed to be organic, growing, changing, burgeoning. When, however, we examine these Japanese corners for contemplation, we see that it is their perceived bareness that renders visible their possibilities. Purling brooks are not necessary for understanding, nor deep pools for profound and personal depths.

Just as the Japanese tea ceremony and the ikebana flower arrangement make frugality a virtue, creating with the simplest of means a world of stillness and beauty, so the rock garden creates an ideal landscape, a garden for the mind.

One might compare these seemingly severe stone gardens of the East to those floral gardens with which we are more familiar in the West. The gardens of Versailles, for example, are based upon a number of familiar assumptions: that man is lord of the universe, that there is a place for everything and everything has its place, that earthly perfection may be expressed in terms of the geometric placement of trees, bushes, flowers. This is an anthropomorphic notion based upon simple certainties.

The gardens of the East are no less anthropomorphic but their assumptions are not those of post-Renaissance Europe. Rather, these gardens were influenced by a more basically religious thought – it was esoteric Buddhism that gave the Japanese garden its philosophical model.

Here, the garden was like a mandala, a symbol of the universe as seen in the Hindu religion, or the Buddhist. This the believer viewed and through it understood. In it, the believer recognized a replica. It was a means of meditation that mediated between the individual and nature itself.

In the stone gardens of Japan, the meditative view is simplified, rendered down to its elements, reduced (or enriched) to its essence. In its way it assumes just as much as does Versailles (and it is certainly as consciously designed) but what is assumed is far different.

Of what this consists the reader will learn in the following valuable pages. A Japanese attitude toward nature lies in the constant endeavor to extract the essence of a flower, of a stone. But in order to accomplish this, one must recognize the nature of what is being viewed.

The original view, the natural stone, however, is never natural enough for the Japanese. Rather than working against nature as does, let us say, Versailles, the Japanese gardener works along with this nature that is being revealed. He or she parallels the grain of the material. There is pruning and placing but these result in the revealing of a line that nature originally created. It is this that we contemplate. Indeed, the emergence of this line, this view, is in itself a kind of meditation.

To contemplate the stone garden is to gaze upon an emptiness that leads to enlightenment. Showing us how this happens, how this verdant future comes from the contemplation of a seemingly barren past, these bare stones, is the accomplishment of this fine book – the forms and the meanings of the blossoming stone garden.

Donald Richie

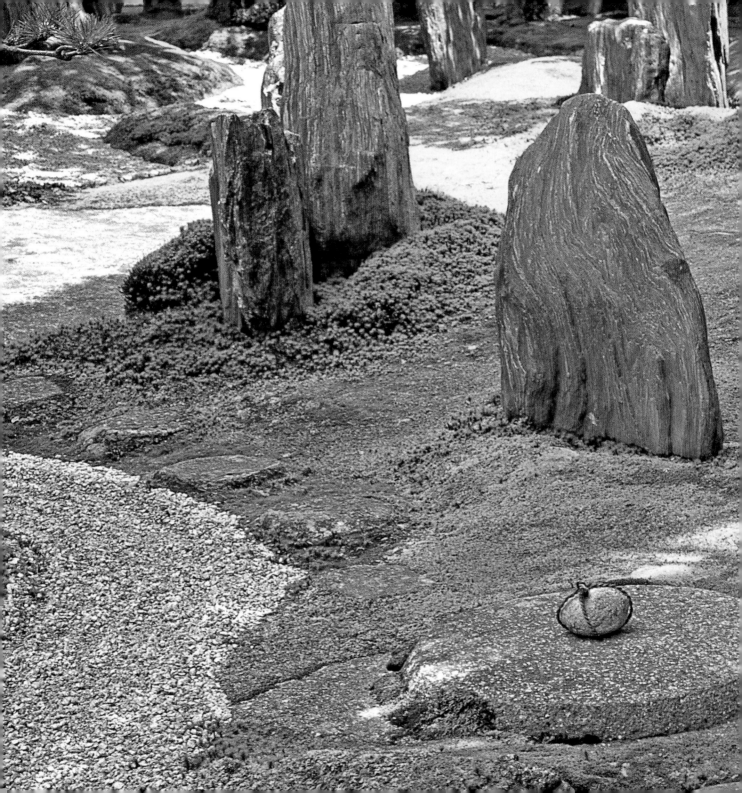

AN INTRODUCTION TO THE JAPANESE STONE GARDEN

Chapter 1

THE ANCIENT WORLD OF JAPANESE GARDENS

Stones were supremely important to Japan's early ancestors. In pre-animistic times, large rocks were used as markers delineating the occupation of property or land. At some point, the original function of rocks was set aside for more mystic purposes. "Driven by the compulsion to make the invisible, mysterious forces of nature and space tangible," the architect Kenzo Tange wrote, "man saw one particular substance stand out in the gloom of primeval nature."

In a world without temples, shrines or religious reliquaries, the natural world provided landscapes and natural features conducive to worship. In this more animistic world, plants, mountains and streams could be inhabited by *kami*, the native gods of Japan. Particularly potent forms, such as waterfalls, imposing boulders and ancient trees were recognized as the most likely places for the gods to reside. In order to communicate with these invisible forces, to pay tribute and promote fruitful co-existence, sacred spaces were created in which large boulders called *iwakura* were placed. These

clearings in the forest, along natural pebble beaches and beside waterfalls, may represent Japan's first "garden" plots.

These "seats of the gods," as the word might be translated, are still found in many parts of Japan, prominently displayed within the compounds of a shrine, roped off in the corner of a village or obscured by undergrowth in the hills. In this ancient pre-Buddhist world, stones were not gods in themselves but the vectors through which the gods could be reached and petitioned. In order to worship stones acting as magnetic fields for the gods, a purified clearing was made around the boulders. The areas were delineated by tying *shimenawa* (rice fiber ropes) and later *gohei* (paper streamers) to old cryptomeria trees that stood around these sites. Large granite boulders in the grounds of Achi Shrine in the city of Kurashiki are a fine example of the type of stones linking ancient Shinto to the stone garden, an association many garden historians and designers regard as the source of inspiration for the later Japanese dry landscape garden. Other ritual spaces were

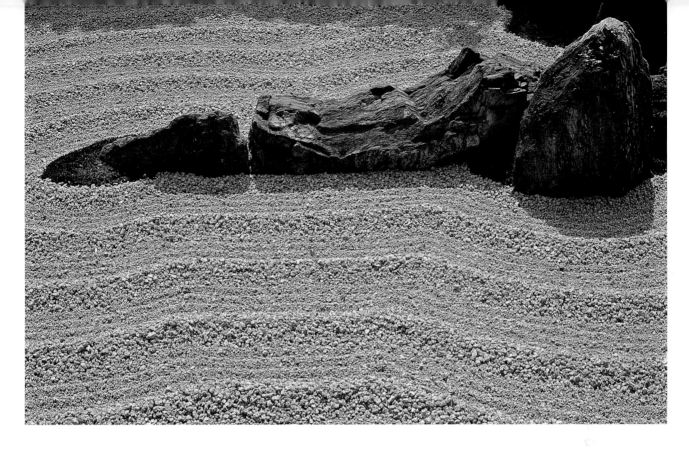

ABOVE This elongated stone at the Zuiho-in Temple represents a peninsula surrounded by waves.

PAGES 10–11 The garden at the residence of landscape designer Mirei Shigemori. The *sekimori-ishi,* a small stone wrapped in straw cord, warns visitors that they must not enter here.

RIGHT An Edo period garden manual depicts men straining to move a large rock.

created in the form of *iwasaka* ("god boundaries"), stone circles where pillar-shaped rocks would surround a central master stone. Though these sites cannot strictly be called gardens, the deliberate grouping of stones in an aesthetically pleasing and spiritually meaningful arrangement may be considered another prototype for the Japanese garden and its concept of a natural order. Intended solely for the purposes of worship and ritual, aesthetic considerations were secondary, although the early Japanese were no doubt impressed by the sculptural beauty of

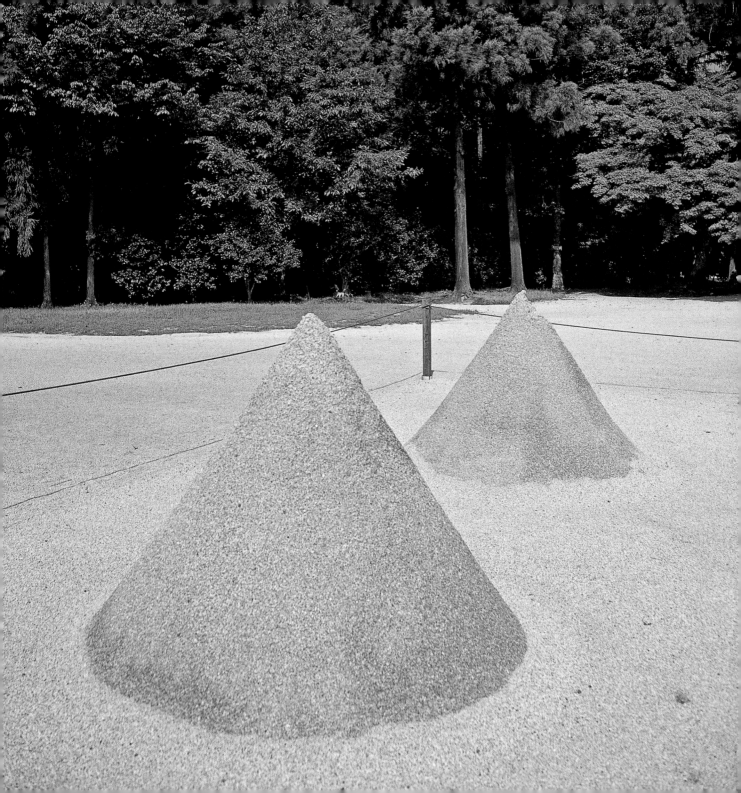

the rocks, aesthetic elements that would be co-opted at a later period by gardeners keen to integrate powerful native design components into their creations. As stones began to be hauled from other sites, the notion of a proper garden architecture gradually took shape, rocks acquiring an archetypical function.

A later development, prefiguring elements that would resurface both consciously and unconsciously in the stone gardens of the medieval period, was the addition of a layer of white gravel or sand around the stones. Known as *kekkai* or "border zones," they marked the boundary between the sacred and the human, but were also the meeting place between mankind and the divine. In an act of ritual purification, light-colored gravel was later spread around the grounds of Shinto shrines, the ceremonial areas outside of clan chief residences and Buddhist temples. These sacred plots (*yuniwa*) also served as spaces for dignitaries to gather and conduct political and religious ceremonies. The cone-shaped mounds of gravel found at some shrines and temples are thought to have originally been used as a reserve stock, as gravel degrades over time. The idea of gravel as a material to enhance ritual purity took the later form of surfacing for the area in front of the main hall of the emperor's palace.

Further evidence of the place of stones in the Japanese psyche and the fact that they long predate any formal religions or philosophies are the Oyu stone circles in Akita Prefecture in the north of Japan, man-made arrangements dating from the late Jomon period (2500–1000 BC).

If stones were used as conductors to communicate with the animistic world, the later Kofun period (AD 300–710) saw their use in a more temporal form, the age characterized by earth and stone burial tombs, many found along the coastal areas of Kyushu and the Inland Sea. Sacred precincts known as *shiki no himorogi* are likewise mentioned in chronicles as early as the eighth century. Strewn with pebbles and marked by sacred ropes, they were used to conduct ritual purifications.

Native Shintoism, an evolved form of animism, discovered in Chinese Taoism a kindred recognition of nature, of rocks, trees, waterfalls and mountains as the powerful home of spirits. Japan's syncretic genius was already evident even as it came into contact with continental Confucianism, Taoism and Buddhism. Taoists visualized paradise as a series of islands floating on an ocean inhabited by invisible celestials. Supported on the backs of turtles, these Islands of the Immortals were believed to actually exist in physical time and space, floating somewhere to the east of the Middle Kingdom.

ABOVE Part of the Genkyu-en in Hikone, the Rakuraku-en stone garden features a superb example of a dry waterfall.

BELOW Wall fortifications at Matsue Castle in Shimane Prefecture represent the importance of stone alongside a traditional wood culture.

When they read accounts by Chinese scholars, the Japanese became convinced that this chain of islands was none other than their own eastern archipelago, their native religion Shinto, with its pantheon of spirits and deities, confirming the islands as the home of the Immortals.

EARLY GARDENS

Although gardening as a conscious art form can be traced to the introduction of formal landscape concepts from China and Korea in the sixth and seventh centuries, as the first great wave of continental Asian cultural arrived in the Asuka, Nara and Heian periods, Japan's prehistoric period as shown already contained key elements that would surface as indigenous features in the stone garden.

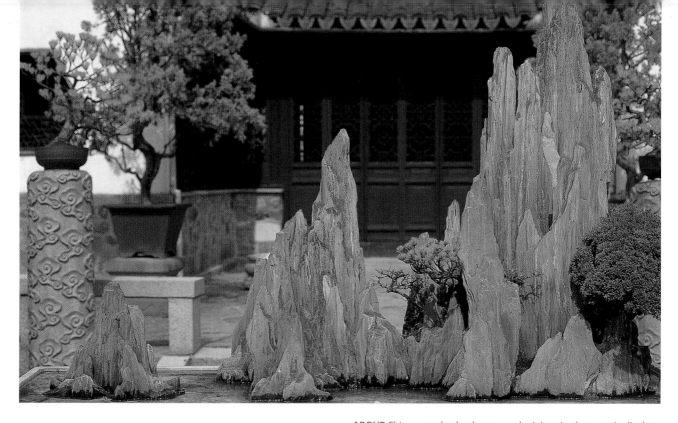

ABOVE Chinese garden landscapes and miniaturized mountain displays like this one in Suzhou, had enormous influence on the design of early Japanese gardens.

Of the many words meaning "garden" in Japanese, the one that best embodies its spirit is, perhaps, *teien*, a compound whose two parts fuse and balance the domain of wild nature (*tei*), as represented in early agricultural communities by the notion of unruly land, and the sphere of controlled nature (*en*), identified with carefully demarcated fields.

Another word, *niwa*, a generic term for garden, existed at the very dawn of Japanese history, before the interaction of an ancient sense of gardening with the formal concepts of later Chinese and Buddhist cultural implants. The word also stands for "open yard" and, by extension, a sanctified gravel space. As agricultural systems developed, the term was used in reference to hard-packed areas of clay in front of farmhouses used for daily activities and rituals associated with seeing off guests.

The courtyards of Shinto shrines and the fore garden of the Kyoto Imperial Palace typify these open, ceremonial spaces. The former often contained two mounds of sand known as *kiyome-no-mori*, which denoted purity. The prototypical Japanese garden was a product of these white gravel gardens and the more elaborate later idealizations of nature found in the Nara and Kyoto regions.

Immensely influential cultural waves from the continent had reached Japan as early as the third century. Formal gardens have existed in Japan since the sixth century, coinciding with influences from the advanced civilization of the Tang Dynasty, then at its zenith. Ono-no-Imoko, head of a diplomatic mission to China, returned to Japan in 607 with detailed commentary on Chinese garden methods. In 612,

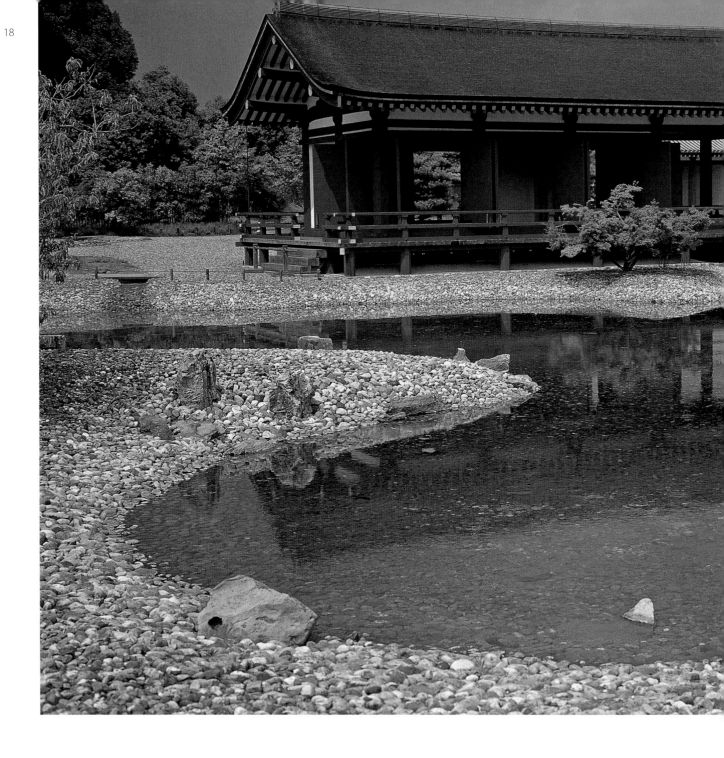

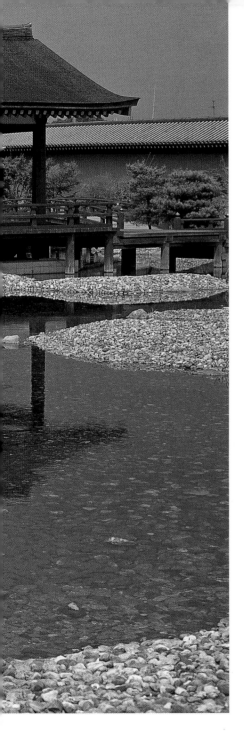

LEFT Unearthed in 1967 and opened to the public in 1998, the pondside shore at To-in (East Palace Garden) in Nara provides a valuable insight into the use of rocks and stones in the early Japanese garden.

a garden inspired by Mount Sumeru, the mythical center of the universe in Buddhism, was constructed for the Empress Suiko by Michiko-no-Takumi after his return from Korea.

As the Japanese began to adopt the architectural forms and aesthetic tastes of an imported Sino-Korean culture, they also borrowed the practice of placing stones in their gardens. The stones the Japanese chose were in keeping with their simpler aesthetic tastes, but would also identify the Shinto spirits and deities that inhabited them with manifestations of nature. The coral and limestone compositions of the Chinese garden, consisting of fabulist piles of energizing rocks full of blowholes and hollows, a playful effect still beloved of the Chinese, were adapted into more subtle, subdued forms by the Japanese, who chose stones with a calmer character, whose surfaces could be best appreciated when washed by rain.

The influence of gardens designed by Chinese and Korean masters waned with the termination, in 894, of all official embassies and missions to China. This was followed by a period of cultural introspection in which ideas were distilled and transmuted into the embryonic features of a uniquely native culture, one suited to its own spatial and climatic conditions, a form of garden design recognizably Japanese. By the end of the Heian period (794–1185), the student had become the master.

PRIVATE GARDENS

The Heian court, comprising a privileged aristocracy with little knowledge of or interest in the peasantry, is said to have placed more importance on the creation and practice of poetry in life, love and protocol than any other society in world history. It was during this era that gardeners attempted to both compress natural features of the landscape and to reflect the four seasons in the walled enclosures of their patrons.

In spring, court nobles would descend from viewing platforms and pavilions to attend musical recitals, float on barges over the surfaces of heart-shaped ponds or engage in poetry competitions, a tradition that likely derives from China. One recalls the Garden of Tranquil Longevity in the Forbidden

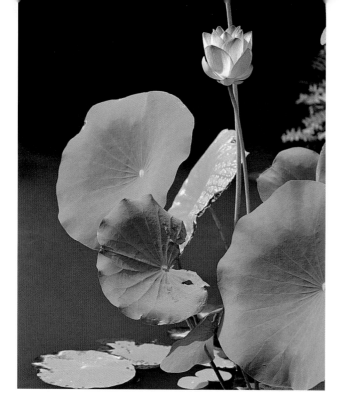

LEFT A lotus at Taizo-in, a sub-temple of the Myoshin-ji complex in Kyoto. In Buddhism the lotus is a potent symbol.

RIGHT Afternoon sunlight emphasizes the sculptural nature of Buddhist iconographic forms carved into the stone at Nokogiriyama, a mountain in Chiba Prefecture.

esoteric temples, *shinden* architecture evolved into the *shoin* style. Originally, the *shoin* was a small study, part of the *hojo* or abbot's quarters overlooking a garden. Gradually, the *shoin* developed into an audience chamber for honored guests, the garden turning from a place to stroll into a *kansho niwa* or contemplation garden to be observed from the interior of a built structure. The garden would contain a sanded courtyard adjacent to the main hall and, space permitting, a dry landscape arrangement. By the Edo period (1600–1868), almost all *hojo* gardens were of this type.

SACRED MOUNTAINS
Korean scholars had introduced Buddhism into Japan by the mid-sixth century, but it seems likely that its presence predates its official arrival date. In the same way that Shinto had started building shrines near or even on sites that had been worshipped for centuries before, Buddhist temples were often built on ancient sacred sites. In the countryside, especially, it is not uncommon to find *iwakura* in the vicinity of temples.

Once understood, Buddhist symbolism was readily incorporated into the designs of early Japanese gardens. Stones served to create the central Buddhist image of Mount Sumeru, known as Shumisen in Japanese. At the center of the Buddhist cosmology, Shumisen is encircled by eight lower mountains and an equal number of seas. This image of storied mountains surrounding a dominant, visibly taller peak, an effect created in the Chinese garden by setting an upright stone above a huddle of lesser rocks, became one of the central themes in the Japanese garden. The similarity of the arrangement to the ancient *iwakura* must have struck the Japanese as felicitous.

City, where there is a symbolic representation of the stream along which the fourth-century Chinese calligrapher and poet Wang Xizhi invited forty scholar friends to sit, drink wine and improvise verses in celebration of spring. With the rare exception of gardens like Motsu-ji in the northern city of Hiraizumi or Nara's carefully reconstructed To-in, only the excavated foundations of such gardens have survived to the present day.

Shinden residences conceived in the Chinese symmetrical style influenced the use of space in the Japanese garden of this period. In order to delineate space, to compress macro concepts and landscapes into the confines of their relatively small estates, a compression or miniaturization was sought. A little south of the *shinden*, a courtyard called the *nantei* was layered with sand. Although this served as a functional space for garden events like archery, cockfights and poetry readings, the sand performed aesthetic and spiritual ends.

During the Muromachi period (1333–1568), under the growing influence of Zen and the establishment of small

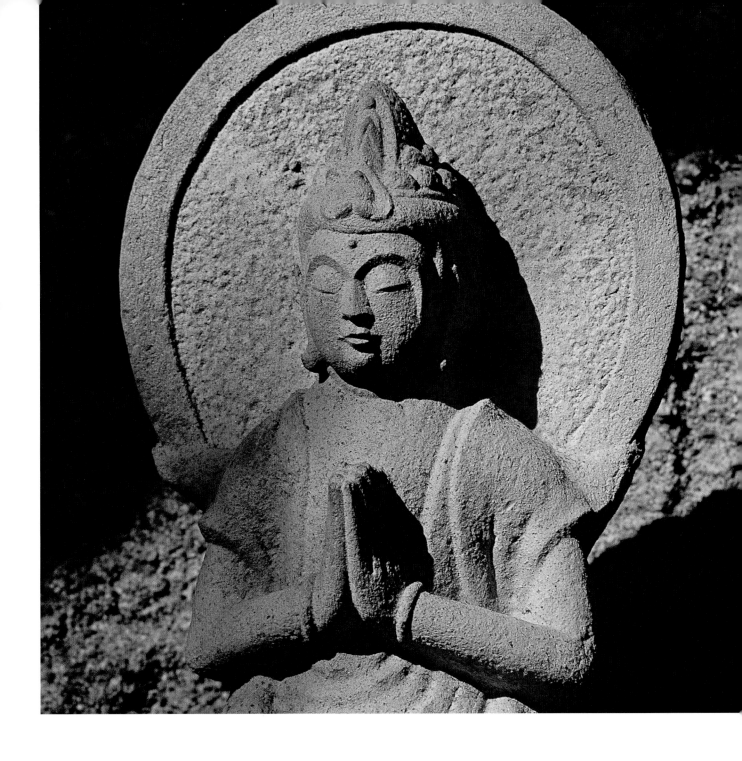

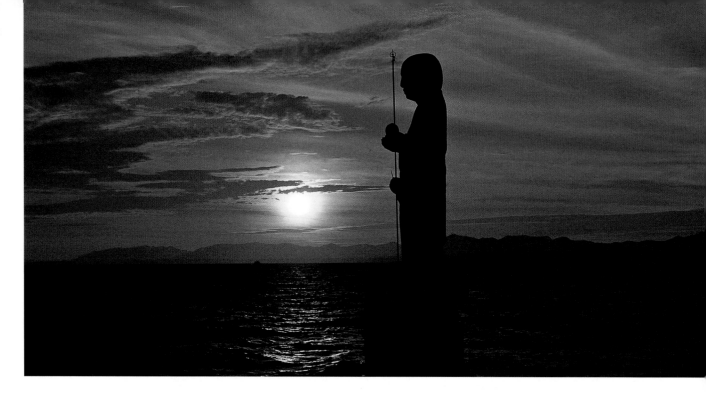

The word *karesansui* (dry landscape garden) is mentioned as early as the eleventh century. The physical absence of water and the use of a replacement element is cited in the eleventh-century garden manual, the *Sakutei-ki*. The manual states: "There are cases where rocks are placed in settings where there is no pond or stream of water. This is called kare-sansui." During this period, dry landscape designs were constructed in parts of the garden that were poorly irrigated.

This has led Japanese garden scholars to conclude that the celebrated dry landscape gardens of the later Kamakura period (1185–1333) and the Muromachi (1333–1568) period were simply an extension of existing forms rather than an invention exclusive to those times. By the end of the Muromachi period, all the uses and pantheistic interpretations of massive forest boulders, rocks and stones had dovetailed into a single, complete design, the prototype of a new, truly Japanese garden form.

Before combining rocks into a garden arrangement, Taoist landscape architects studied them one by one in order

ABOVE A stone Jizo statue on the shores of Shinji-ko, a lake in Matsue, Shimane Prefecture.

to discover their "dragon veins," the geomantic properties and energy flows that Taoists believe connects all physical matter in the world.

The importance of stone and water in the gardens of the Heian era was based on more than just creating pleasing arrangements. Stone setting became part of a scheme to promote good fortune or as preventive measures devised to forestall catastrophes. In order to deter calamities, readers of the *Sakutei-ki* are exhorted to heed taboos regarding the position of upright stones representing mountains, which have the power to either enhance or impede the flow of *ki* (life energy). Stones should never be positioned on the linear extensions of pillars supporting villas, for example, as this will bring misfortune to its residents. Large upright stones must never be placed in the northeast, the devil's gate, as this can facilitate the entry of evil spirits.

Successful stone arrangements seem almost alive, the elements conversing among themselves with an occult vitality, the call and response that has been noted between well-placed rocks resembling the chanting of Buddhist sutras. The idea of the garden designer initiating a dialogue with the elements of the garden is a singularly Japanese approach, probably predating the *Shakutei-ki*, one which urges the reader to "follow the request" of each stone. A dominant stone will begin this orchestration, the other rocks complying with its "requesting" mood.

Quoting from an eighteenth-century encyclopedia's entry on stone, John Hays, in his *Kernels of Energy, Bones of Earth*, cites this thinking: "Rocks are kernels of energy; the generation of rock from energy is like the body's arterial system producing nails and teeth.... The earth has the famous mountains as its support, rocks are its bones." Tellingly, the side of a stone with the finest attributes is called the "face," the top of the stone "heaven," though in the distant past it was referred to as the "head." Arguably, the astringency of these gardens is best appreciated during winter, when, with their greenery removed, rock surfaces are scraped close against the skull.

TRAY GARDENS

If the blueprint of Chinese gardens, with their islands of celestial rock, were much admired and emulated, *suiseki* or miniature stone gardens had a profound impact on the later designs of stone gardens. The term *suiseki* literally means "water stone" (*sui*, water; *seki*, stone). Originating some 2,000 years ago in China, interesting, rare or well-formed stones were placed and displayed in watered trays. Imitations of classic landscape painting, they were also associated in the Chinese mind with the legendary mountains, islands and seas represented in Buddhist and Taoist texts.

Chinese emissaries brought examples of these water stones to Japan in the sixth century. Given the Japanese veneration of stones, it is not surprising to learn that the Empress Regent Suiko expressed her admiration for these miniature landscapes. These gifts from the Chinese imperial court would have reflected the prevalent tastes of the Middle Kingdom for fantastically formed stones replete with cavities, craggy, eroded surfaces and soaring verticals. Besides their natural beauty, as perceived by the Chinese, there were philosophical considerations in the tray arrangements, the stone representing the hard, resistant male force *yang*; water standing for female *yin* qualities: moist, dark, sensitive and yielding. As with full-scale gardens, the Japanese adapted these forms to their own tastes.

Bonseki ("tray stones"), an alternative style in which stones form the main, and sometimes only, element in suggesting a natural scene, bear an extraordinary similarity to Zen temple gardens. The same triangular balances and asymmetry found in *karesansui* are there. The more planar, highly compressed character of Muromachi period stone gardens suggest that tray landscapes may have been a key influence in their creation. These highly portable works were easily brought back to Japan from the continent, and frequently displayed as cultural artifacts during the Kamakura period.

Well suited to space-starved Japan, it was natural that the art of *bonseki* should also have been modified and refined in Japan, where both agriculture and horticulture were practiced within a highly confined environment demanding self-discipline, resignation and manual dexterity, where nature and miniature works of art were much admired.

The relationship between microcosm and macrocosm, the analogy between stones and mountains and the corresponding idea that the beauty and force of the greater mass is concentrated and refined within the smaller one, is a principal upon which Japanese stone gardens would be predicated. Chinese scholar Du Wan's twelfth-century *Yunlin Shipu* (Cloud Forest Inventory of Rocks) claims that "Within the size of a fist can be assembled the beauty of a thousand cliffs." Garden historian Teiji Itoh has observed, conversely, that while the common view is that the Japanese garden embodies the idea of miniaturization, the reverse is closer to the truth, that the design is "an attempt to expand the garden to almost cosmic proportions."

Chapter 2

GARDENS OF THE HIGHER SELF

ABOVE The stone garden at Myoshin-ji Temple, in *Tsukiyama Teizoden* (Building Mountains and Making Gardens). The lines point out the force flows and the relationship between rocks.

OPPOSITE The shadow of the truncated cone at Ginkaku-ji Temple in Kyoto. The cone has been compared to Mount Fuji and Mount Shumisen, the central peak in the Buddhist cosmology.

The Chinese were probably the first to recognize the use of gardens as places for quiet discourse of a literary nature, and as aids to meditation. The sixth-century BC Taoist philosopher Lao Zi spoke of gardens as spiritual aids that could promote a state of emptiness that would lead to enlightenment.

If creating a likeness of external nature turned in the case of stone gardens to an expression of quintessential, interior nature, the second wave of Chinese influence that characterized the Kamakura era (1185–1333) is noted for the ideas of the Sung Dynasty literati and the arrival of Zen Buddhism and its focus on the inner workings of the mind.

Zen's stress on self-reliance as opposed to salvation, truth instead of the dogma promulgated through forms of esoteric Buddhism favored by the Heian aristocracy, had great appeal. The common quest of these three movements was to penetrate to the truth hidden beneath the surface reality of life and nature. This drive toward inner truth led to the scouring off

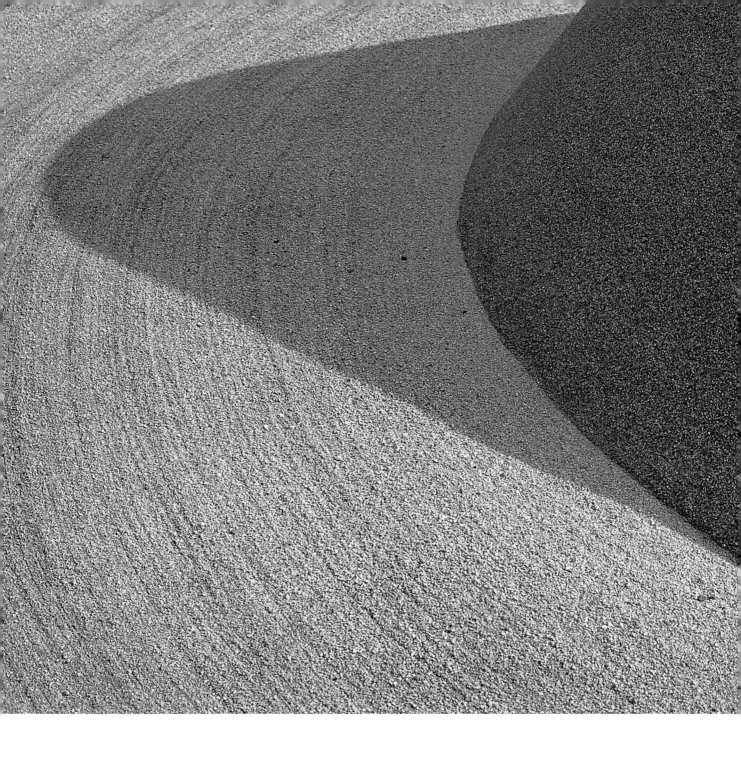

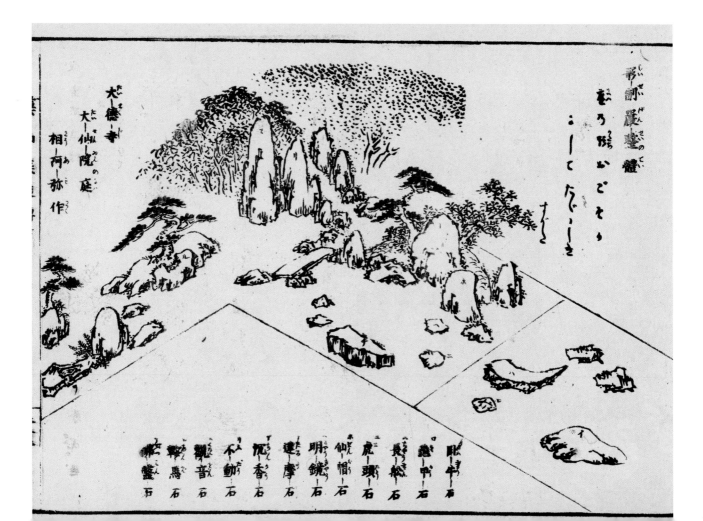

of superficial ornamentation, consummated in the reductive garden designs of medieval Zen temples and, to a lesser degree, the gardens attached to warrior villas.

An important conceptual shift took place at this time. While the materials used in garden design continued to be natural, these digests of nature achieved a point of near abstraction. The gardens from this era replicate the inner essence of nature rather than its outer forms. A shift in taste also took place at this time, with the influence of Zen and the rise of a warrior class more drawn to stones of a darker, more austere, subdued and unpretentious nature. Seeking the profoundly subtle, they chose rocks that were more suggestive than explicit.

Consistent with these ideas and tastes, the great Zen priest and garden designer Muso Soseki (1275–1351) pushed the evolution of stone gardens a step further with the design

BELOW The exquisite Daisen-in from the illustrated garden manual *Tsukiyama Teizoden* (Building Mountains and Making Gardens). The names of individual stones are listed at the bottom of the illustration.

ABOVE A solitary rock island in a sea of gravel at Ryoan-ji Temple.

of Saiho-ji in Kyoto and Tenryu-ji in the Arashiyama district on the city's borders. In this latter garden, Soseki, the first Japanese landscape designer to suggest that gardens could be used as aids for meditation, shifted the viewing mode from one of strolling around the garden to a seated position, usually from the abbot's quarters, one more suited to contemplation.

ZEN WAVES

Zen Buddhism's rejection of superstition transformed stones into more purely artistic, abstract features of the garden. In these Zen-style gardens, an atmosphere conducive to meditation was created. As devices to aid meditation, these gardens were also viewed as works of art, created within set frames designed to be viewed in the same way as a painting or a hanging scroll. Early examples of the contemplation garden are the sublime, now very famous, garden at the Ryoan-ji temple, conceivably built as early as 1499, and another Kyoto landscape, the northern garden of the Ryugen-en, dating from 1517. The Ryoan-ji is the best-known example of the *mutei* or "garden of emptiness."

Spatial void, the nourishing emptiness that forms the heart of the contemplation garden, is a device like any other, one defined by the word *ma*. Framed in enclosures that heighten the sense of premeditated art, *ma* in its Buddhist form is represented by the concept called *mu* (nothingness), a central precept of Zen Buddhism. Stone garden designers use *ma* as an aesthetic technique to promote *yohaku-no-bi*, the beauty of empty but articulate space.

Toshiro Inaji has written that "The ideal form is a 'conceptual prototype' that is divorced from a real, physical form." Beyond the actual appearance of the garden is a second, transcendent form, one that can inspire multiple interpretations. It is probably fair to guess that these gardens also existed as pleasant rather than solemn retreats for those living in temple monasteries. Garden writer Tachihara Masaaki has commented that "with the development of Zen culture, the dry landscape garden was devised as the Zen monk's ultimate form of recreation."

TURMOIL AND ORDER

Stone gardens evolved as much from religious and aesthetic preferences as from changing social-political conditions, principally the ascendancy of a warrior class and their aesthetic of frugality. Marc P. Keene, in his book *Japanese Garden Design*, makes a strong case supporting the view that the confined, almost escapist designs of stone gardens were a response to the turbulence of the times. "Gardens, in keeping with the nature of society in general," he writes, "became withdrawn, tightly enclosed, and introverted," personifying themes which were often closer to the fabulist landscapes of China's Tang poets than to the embattled and ravaged countryside of feudal Japan. Curiously, the backdrop of social instability and the tendency toward denial and seclusion seen in gardens was matched by a period of economic growth and a flowering of the arts. In a climate of fear and uncertainty, Zen temples became unofficial sponsors of the arts, providing a relatively safe haven for those still able to contemplate the finer things in life, including the creation of Noh dramas, linked verse and gardens.

Savage internecine struggles, known as the Onin War, which raged from 1467 to 1477, left half of Kyoto destroyed. The new city that grew from the scorched earth and ash of highly inflammable wooden buildings was strongly influenced by Zen priests, who advanced the development of dry landscape gardens. Economics may also have played a part in the advocacy for smaller, more easily maintained gardens, as land and construction costs rose. The gardens that emerged during this period were more refined and abstract in nature, a style believed to have been developed at Myoshin-ji and Daitoku-ji Temples.

As the focus of cultural life also shifted from the palaces of the aristocracy to the residences of samurai and the Zen monasteries which they supported, architectural priorities also changed. The *shinden-zukuri* architecture of the Heian palaces, with their pond gardens, changed to the *shoin-zukuri* designs of Zen temples, where gardens were placed in front of the abbot's quarters. Built in an irregular design, temples, monasteries and villas had less space for the disposition of gardens. For the Zen adept, this posed few problems as, according to Zen thinking, scale is a relative matter. Infinite space, a magnum universe and a miniature one are equally accommodated.

The gardens are characterized by an absence of ornamentation and an acute relationship between sculptural rocks and the luminous expanse of sand and gravel on which they sit. The overstimulation experienced in the Japanese paradise and stroll garden, where visual and narrative details are bountiful, is exchanged for a severe reduction of nature and the cosmos to a small planar unit where, distraction-free, a state of awareness through meditation becomes possible. In this newly induced state of mind, the essential symbolism of the garden elements, stones standing for the eternal structure of the universe, sand and gravel for the temporary nature of the phenomenal world, reveals itself.

RIGHT A large *tatami* mat room used by visitors for a moment of quiet contemplation faces onto this inner garden at Kennin-ji Temple, Kyoto.

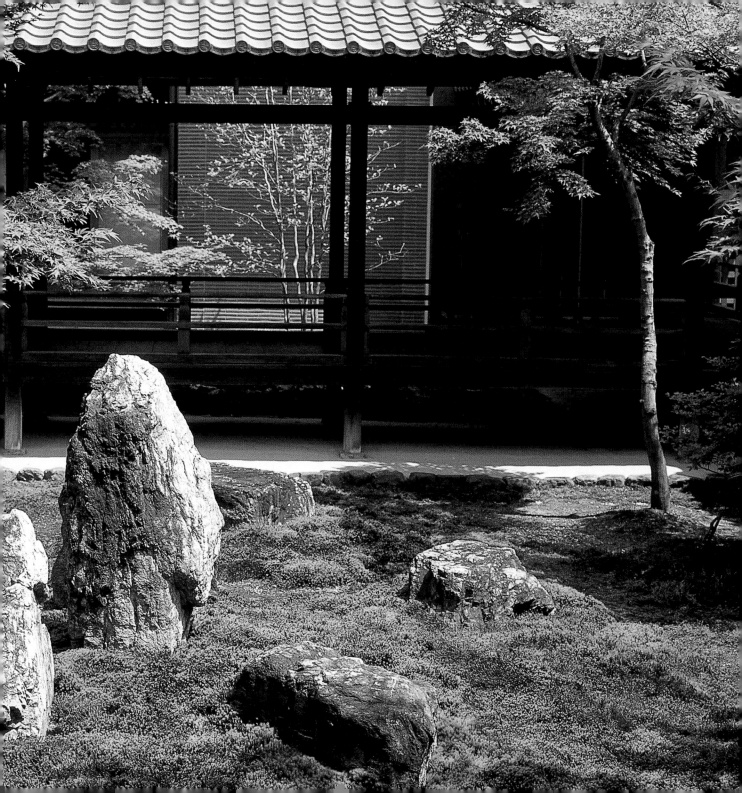

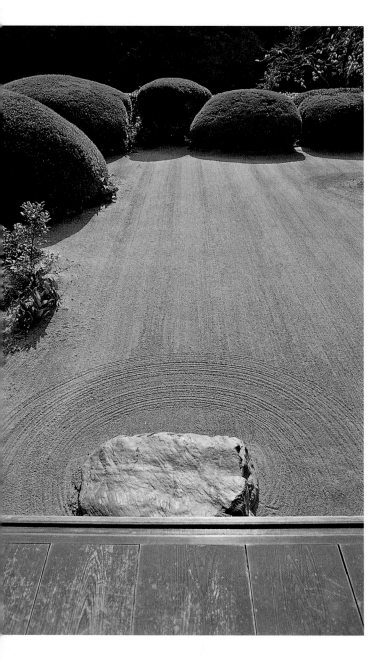

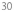

LEFT A fluid movement of space at Shisen-do, from its time-worn verandah to the carefully clipped bank of azaleas in the distance.

ENLIGHTENMENT AND ALLEGORY

The stone and sand gardens most commonly found in the courtyards of Zen temples were now expressly referred to as *karesansui*. The literal meaning, "dry-mountain-water," refers to the nature and composition of the garden in which mountains, rivers and seascapes are created solely with the use of rocks, sand and gravel. Stone gardens existed during the Heian period as features of larger gardens that could be entered and viewed from differing angles, but the medieval stone gardens of the late Muromachi period were designed to be viewed from an adjacent hall. These *kansho niwa* (contemplation gardens) represented one of the great creative leaps in the history of the Japanese garden. Viewers were now required to explore the garden and its depiction of scenes allegorical to Zen Buddhism mentally rather than physically.

Garden designers left Zen Buddhist implants in their works in the form of allegorical references that could be used not only for contemplation but also instruction in Zen teachings. The transfiguration of allegories into physical form through the use of rocks is nicely illustrated in the stone arrangement called *ryu-mon-baku* ("dragon's-gate-waterfall"), a popular motif in the dry landscape garden. The arrangement is based on a Chinese anecdote in which a legendary river flows toward an almost insurmountable three-tiered water-fall. If a fish proves strong enough to swim to the top, it will be turned into a dragon. The Japanese reinterpreted the story as an allegory of Zen study, by which meditation and fierce self-training could lead to enlightenment.

The diminutive garden at the Daisen-en temple in Kyoto represents a highly visual allegory for the passage of life, starting with a dusting of white sand threading its way through the upright boulders at the rear of the scene, a river head that spurts out of a mountain ravine that symbolizes

the source of life, reality and truth. The stream of sand gains in strength and complexity, flowing around tortoise and crane islands standing as symbols of longevity, before debauching into a wide expanse of raked sand representing an ocean, which might also be understood as the peace of eternal paradise. Although flowering trees and bushes are occasionally planted in these gardens, essentially the gardens are not concerned with seasonal change as they represent the concept of timelessness.

Such gardens neatly embody one of the main principals of Zen period gardens, which are not imitations of nature but a transcendent form of it, which, through artifice of design, reveals its essence. Revealingly, there are no explicit links made in illustrated Japanese garden manuals between Zen and stone gardens. It is rather a matter to be implicitly understood, the gardens being created primarily as heightened cultural ambiences.

RIVERBANK PEOPLE

Contact with soil was considered unclean in Japan, particularly for the upper class. The exception seems to have been the working conditions of Zen priests who, less affected by social attachments and rank, were expected to maintain gardens: rake gravel surfaces, collect fallen leaves, weed, and remove dead animals. Originally, semiprofessional gardeners connected with two stone-setting schools trained a class of semiprofessional garden-making priests known as *ishi-tate-so*. Ninnaji temple in Kyoto was the headquarters of one of the two principal organizations, the other the Saga School headed by Muso Soseki. The expression sprang from *ishi wo taten koto*, "the art of setting stones," the term used by Kyoto aristocrats who, having no specific expression for gardening, defined it by the central process of stone placement.

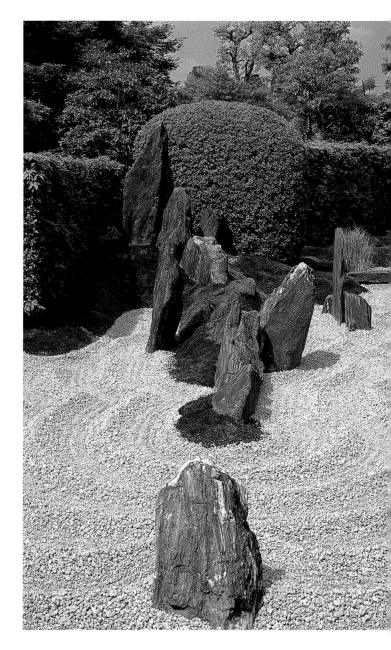

RIGHT The design at Zuiho-ji represents the world of Chinese mythology. The large rocks at the back ascend to the central rock symbolizing Mount Horai, home of the Immortals.

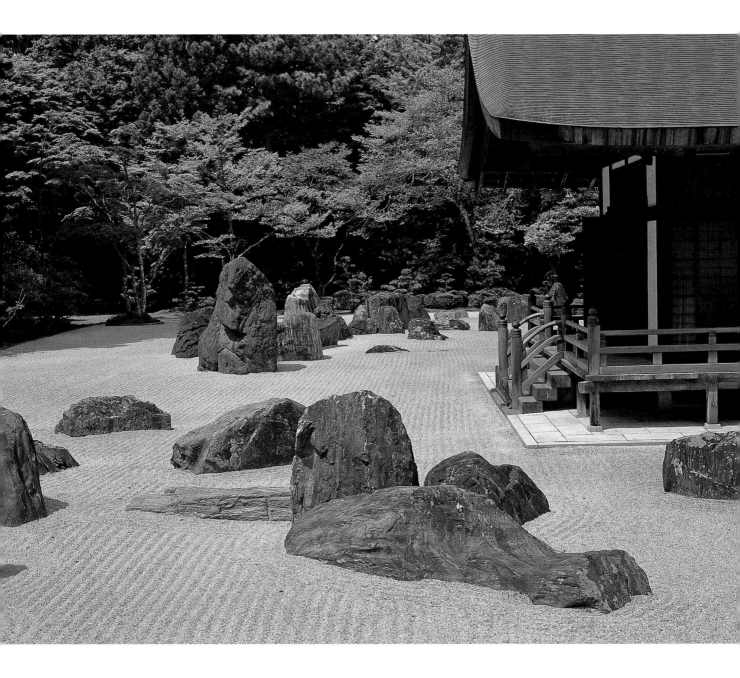

LEFT Banryutei, the dry landscape garden attached to Kongobun-ji Temple on Mount Koya, comprises 140 granite rocks, making it the largest stone garden in Japan.

Garden assembly, once the province of these rock-setting priests, gradually passed into the hands of *sensui kawaramono*, the riverbank underclass of garden builders, some of whom were able through their immense talents to earn the respect of both the priesthood and the shogun, the military rulers of the time. The *mono* of the designation stands for "thing," clearly stigmatizing this pariah class as "non-humans." A combination of Buddhist and Shinto taboos against the killing of animals and other unclean acts placed these people, forced to undertake the most obnoxious and sordid forms of work (the slaughtering and skinning of horses and cows, the execution of criminals and the burial of the dead), well beyond the sphere of a rigidly hierarchical class system, with the nobility and clergy at the apex and, in descending order, warriors, farmers, artisans and merchants. The trade of stripping and tanning hides for armour, another impure livelihood, required large quantities of water, forcing them to build their abodes along the banks of waterways, such as the Kamo River in Kyoto.

The *kawaramono* were essentially corvée laborers, who were also employed in the physically demanding work of digging irrigation ditches, trenches, terraces and wells, in addition to the excavation of areas for garden ponds and hills. In a work by Madenokoji Tokifusa entitled *Kennaiki*, stigma becomes prohibition in a passage that states: "In the past, outcasts (*kawaramono*) have been permitted in the imperial palace to do gardening; but, since these people are unclean, as of last year such permission is no longer granted. This year, among the menial laborers, only those of the class called *shomoji* will be employed in palace gardening." Though both groups belonged to the lower orders, it seems that the *shomoji*, who made their living by going from door to door reciting sutras for the good fortune of the dwellers within, were regarded as a notch higher in the social scale.

With time, however, *kawaramono* became indispensable because of their great skill in selecting and planting trees and placing rocks, in many cases surpassing their masters in the art of gardening. Their rise was in part due to the help of Zen priests who, besides being their garden patrons, guided them in Zen philosophy. Denied access to the secrets of the ancient garden manuals, but with Zen priests as their mentors, a new collaborative style of dry landscape garden evolved.

Though to a considerable degree it was these men who were responsible for the exquisite stone gardens of the Muromachi period, their work has gone largely unacknowledged. The Ryoan-ji garden in Kyoto, for example, routinely attributed to Soami, is quite likely to have been either designed or to have had a significant design input from two of Japan's *kawaramono* whose names, Seijiro and Kotaro, are carved into the concealed back part of a rock in the garden. Although their skills were acknowledged by the warrior class and later aristocracy who commissioned the building of gardens, their contributions remain largely unaccredited. Ironically, it may very well be that that some of Kyoto's "purest" gardens were created by the hands of men regarded as impure to the point of being inhuman.

It was still a rare exception when art was placed ahead of social prejudice, but this happened with the garden master Zen'ami (1386–1482), a protégé of the enlightened shogun Ashikaga Yoshimasa. Zen'ami lived in a riverbed area with other *kawaramono* and with outcast refugees from peasant uprisings. These were places where thousands of corpses were deposited during famines. The man described as foremost under heaven in the planting and setting of rocks had to wait to the age of 73 before being officially recognized. The possessor of a truly transcendent intellect, it is almost impossible to imagine, as Teiji Itoh has observed, what thoughts may have run through Zen'ami's head as he pondered garden designs in his riverbed home surrounded by wretchedness and death. The two laborers who constructed the garden at Ryoan-ji may well have been his apprentices.

As works of religious art, gardens owed a debt not just to Zen precepts but also to the Chinese ink-wash painting of the Southern Sung and Yuan periods, sufficiently predating the Muromachi era for their influence to have become entrenched. Many of these paintings were landscapes depicting the figure of a hermit scholar against the backdrop of a vast natural world of mountains, ravines and thundering waterfalls, a world of compressed rock relieved only by a solitary tree or two, the convention usually requiring one or two suitably gnarled pines. The sparseness of the design elements and the implied search for inner truth coincided with a prevailing taste for austerity that held enormous appeal for Japanese priests and the painters who benefited from the enthusiastic patronage of the Zen temples of Kyoto. Temples were less interested in the paintings per se than in acquiring landscape images that could be viewed as metaphors for religious principals or tools for personal growth and enlightenment.

Garden designers appropriated the large spaces left empty on canvases with expanses of white sand. By setting stones in this blank, gardeners replicated ink paintings by creating depth of field and an angularity and tension between the surfaces and edges of rocks that echoed the almost cubist rock clusters seen in ink painting. By choosing white or gray sand, dark stones and subdued emerald-colored plants, an effect similar to the semi-monochromatic tones of the paintings was achieved.

The austerity of Muromachi era stone gardens was supplanted by a more flamboyant approach during the later Momoyama and Edo periods, which saw a renaissance of the dry landscape garden. More lavish concentrations of rock are seen and rich clumps of exotic plants appear in gardens now intended more for appreciation than contemplation.

The Edo period (1600–1868) garden replaced the stripped down austerity of a previous age with the playful ornamentation of stone lanterns, miniature bridges, water basins and exotic plants. These were augmented with religious touches: carved bodhisattvas, temple tiles and half-buried sections of roof pediments. Though this period is often

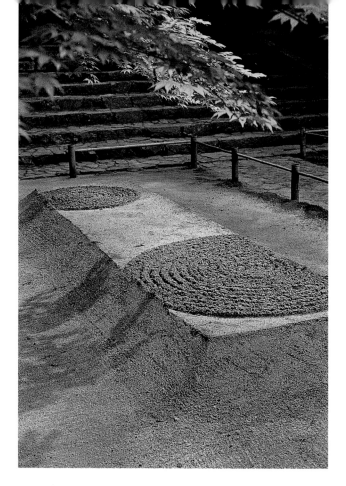

criticized for its superficiality and paucity of ideas, the Edo era was not without its brilliant individual gardens, its own innovations. One design principal introduced at this time was the deliberately random placing of rocks to create a sensation of spontaneity. These rocks are referred to as *suteishi*, "nameless" or "discarded" rocks.

It was during this period also that another innovation, *o-karikomi* (topiary art), was introduced in the form of clipped bushes and evergreen shrubs representing clouds, stormy seas, treasure-laden ships or the outline of Mount Horai. The gardener who perfected this form was Kobori Enshu (1579–1647). There are fine examples of Enshu's living sculptures at the Daichi-ji Temple garden in Minakuchi and at Raikyu-ji, a Zen temple in Bitchu Takahashi.

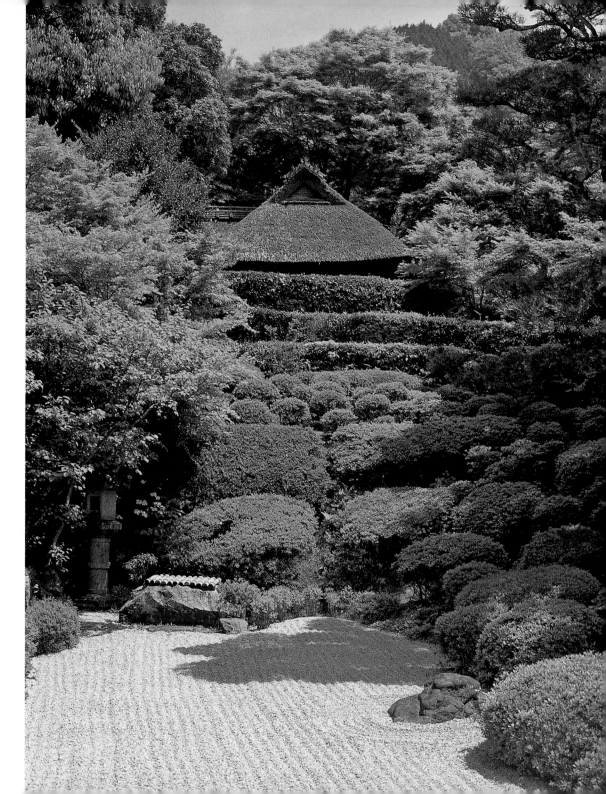

LEFT A sand mound at Honen-in, a Jodo sect temple located on a wooded slope in Kyoto. Priests periodically change the design to reflect the seasons.

RIGHT The stepped banks of azalea at Kyoto's little-visited Kompuku-ji Temple create the illusion of a mountain valley. The restored cottage at the top of the garden once was the temporary home of the great *haiku* poet Basho.

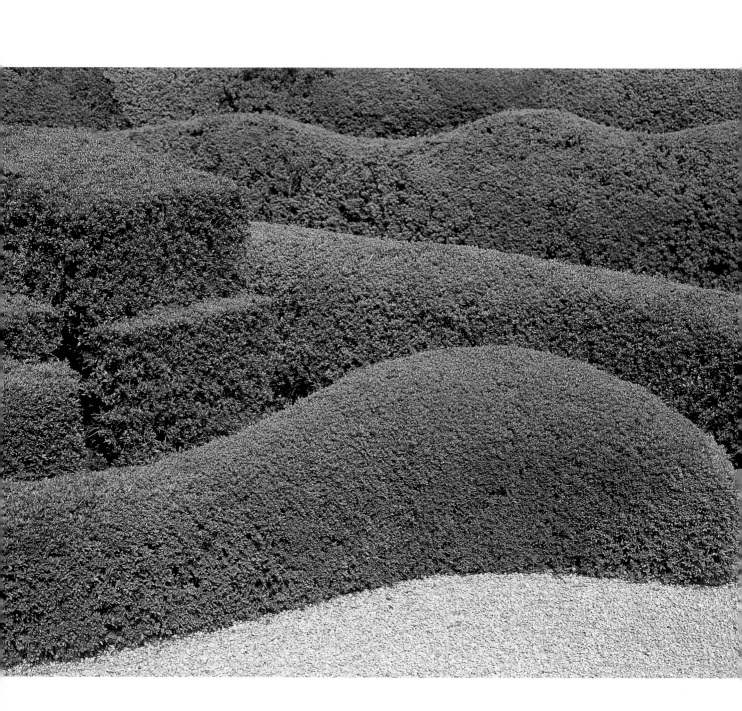

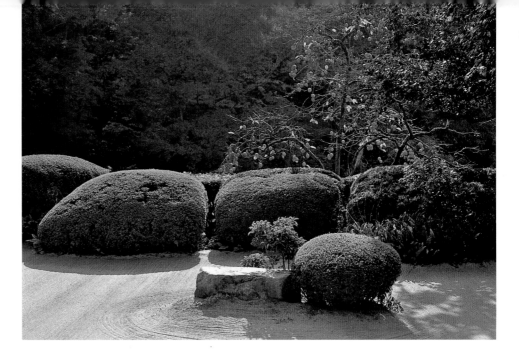

LEFT The magnificent topiary at Daichi-ji Temple in Minakuchi, Shiga Prefecture, represents a treasure ship buffeted by waves. The design is attributed to Kobori Enshu but may have been created by one of his pupils.

RIGHT Autumn light filters through a persimmon tree at Shisen-do in Kyoto. Fruit trees, even as borrowed views, are relatively rare in stone gardens.

STONE AMBIGUITIES

For those who visit Japan's *karesansui*, seeing things in the dark mirror of the stones has become a requisite part of the experience. The analogy between such gardens and states of mind is, perhaps, inevitable: human nature, if left unchecked, turns into an unweeded wilderness; stone gardens, making a virtue of opposing nature, overcoming, even improving on it, are by contrast models of order and astringency.

Prominent gardens have acquired an intellectual commentary that was largely absent before the advent of cultural tourism. Starved of the mysticism older societies took for granted, stone gardens, like Stone Age monuments, are now lauded for their depth and complexity, for their metaphysical and iconographic qualities. In *Themes in the History of Japanese Garden Art*, however, author Wybe Kuitert, remarking on the assumed link between gardens and Zen precepts, contends that temple gardens and those attached to samurai residences were commissioned with the intention of merely producing an "enhanced cultural ambience."

The connection between Zen and stone gardens, then, is to some extent an assumed one. There are few direct allusions to "Zen gardens" in Japanese texts before the 1950s. The yoking together of the two ideas as a popular concept in print occurs for the first time in American Lorraine Kuck's 1935 publication, *One Hundred Kyoto Gardens*. Kuck, it seems, was a temporary neighbor of Daisetz Teitaro Suzuki, the foremost exponent of Zen in the West. Suzuki, a paragon in his writing of non-attachment and self-restraint, stops short of using the term "Zen gardens" but affirms that the dry landscape form is an embodiment of "the spirit of Zen."

Alan Watts, in his influential book, *The Way of Zen*, characterizes the gardens not so much as paradigms of Zen thinking but as works of art inspired by them, the "media the simplest imaginable; the effect is as if man had hardly touched it, as if it had been transported unchanged from the seashore; but in practise only the most sensitive and experienced artist can achieve it." This seems a fair assessment for any art sufficiently accomplished that it transcends its own techniques. Echoing and advancing the characterizations of Kuck and Suzuki, Watt's book was, tellingly, first published in 1957. Introducing a new term, the "Zen gardener," the writer asserts, in the manner of appealing Zen oxymorons like

"formless form," that the gardener "has no mind to impose his own intention upon natural forms, but is careful rather to follow the 'intentionless intention' of the forms themselves," that the gardener "ever ceases to prune, clip, weed, and train his plants, but he does so in the spirit of being part of the garden himself rather than a directing agent standing outside. He is not interfering with nature because he is nature, and he cultivates as if not cultivating."

The melding of gardens and Zen in the popular imagination, the assigning of a presentational mode, a commentary, to explain them, was all but complete by 1939 when Shigemori Mirei landscaped the garden of the abbot's hall at the Tofuku-ji temple in Kyoto, the designs expressly intended to represent "the simplicity of Zen in the Kamakura period with the abstract construction of modern arts."

Unlike the verifiable Zen influences found in arts and disciplines such as archery, the tea ceremony and ink-wash painting, the process of garden design is highly premeditated and deliberate. As Leonard Koren has stated in his book, *Gardens of Gravel and Sand*, "The gardens are not the result of mystical insights or spontaneous action.... It is unlikely that any 'flash of insight' is involved, or that the gardens are meant to inspire such."

While taking stock of the obvious Zen elements that gardens have acquired in the course of time, Zen principals have been consciously applied to the gardens. There is very little historical commentary to support claims that the gardens were originally designed with Zen notions in mind. The expression "Zen garden," used epithetically, is one that writers have been happy to adopt. Interestingly, the Japanese themselves have now started to adopt the description in preference to the more exacting *karesansui*.

Although the link between the two things is now firmly entrenched in the mind, the effusive sobriquet "Zen garden" can be potentially misleading. The world-famous garden at Ryoan-ji provides a cautionary example. Here is a design that has somehow acquired almost talismanic properties. There are

even those who believe that this trance-inducing installation is not simply a garden but an ancient instrument, a sorcerer's lodestone, a navigational tool into the mystic.

David A. Slawson, commentating in his *Secret Teachings in the Art of Japanese Gardens* on how and why Ryoan-ji has acquired so much respect in the West, suggests that it is because of "its presumed similarity to non-representational minimalist or abstract art," but that, in the context of the Japanese aesthetics that were responsible for the creation of the garden, "it would be more accurate to recognise its quality-oriented design as having been inspired by a direct encounter with the powerful forms and kinetic energies actually present in the natural environment."

The more humdrum or routine maintenance and upkeep of gardens and the transmission of garden practices is still the domain of monks. Zen thinking and gardens connect in the act of daily cleansing and maintenance. The beloved image of rows of Zen priests and acolytes sitting in the lotus position meditating before sand cones in a Zen garden may be a rare sight, but the daily chore of raking sand into aquatic patterns, a task assigned to promote self-discipline and humility, is a common one for those up early enough to see it. So too the rigors of monotonous food, unheated rooms, alms collecting, seated and walking meditation, and menial tasks like rubbish collecting, toilet cleaning and digging ditches, all seen as good opportunities for Zen practice.

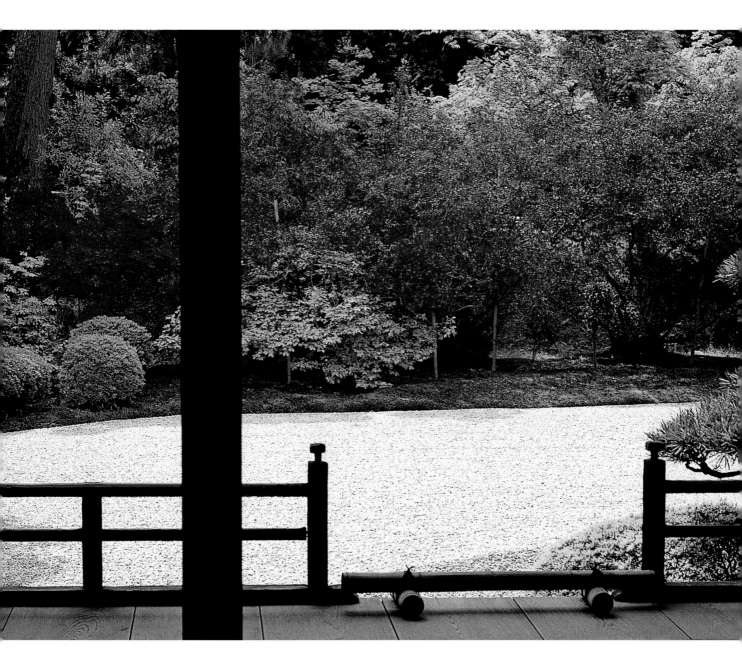

"ORIGINALLY THERE IS NO CONDITION OF LARGE OR SMALL IN ANY OF THE THINGS IN THE UNIVERSE: THE LARGE AND THE SMALL ARE IN THE MINDS OF HUMAN BEINGS. THEY ARE NOTHING BUT ILLUSORY APPEARANCE."

Muso Soseki, *Dream Dialogues*

Chapter 3

JAPANESE GARDEN AESTHETICS

In an imperfect world, stone gardens represent an idealized environment, the world as it should be, all the right balances and dynamics firmly in place, nourishing the mind.

Our clear distinction between animate and inanimate was not shared by the ancient Chinese, whose understanding was that all natural phenomena were infused by the psychophysical energy known as *ki*. Balancing the polarized energy of *yin* and *yang* (*in* and *yo* in Japanese) within the body, controlling the flows of *ki* in order to promote harmony between the body and the circulation of cosmic energies beyond it, was and is an idea accepted in both principal and practice by the Japanese.

One of the practical applications in the early Japanese garden was the site layout concept known as *shishin soo*. This ancient Taoist belief, which was later incorporated into practices connected with *feng shui* (geomancy), is based on the idea that designated land areas are protected by four gods: *seiryu*, the Blue Dragon; *byakko*, the White Tiger; *suzaku*, the Red Phoenix, and *genbu*, the Black Tortoise. Tied to ancient Asian astrology,

the layout of both the ancient Chinese capital of Xian and Heian-kyo (present-day Kyoto) are based on this concept.

The immediate beauty and freshness of the Japanese garden, seamlessly blending nature and art, can only be fully revealed when such elements, concepts and the representations that embody them are understood. While its symbolic intentions are not hidden, one has to know the garden lexicon to read them. Depending on the ingenuity of the designer, a jagged rock may stand for a distant mountain or waterfall, a stone lantern may turn out to be a lighthouse and raked pebbles and sand a serpent's spore or the sensual curve of a seashore.

ESOTERIC REFINEMENT

A number of key aesthetics associated with the refinement of the Heian court and its co-opting of later Buddhist concepts were added to the process and appreciation of garden design at this time. Elevating these stone tableaux from the merely

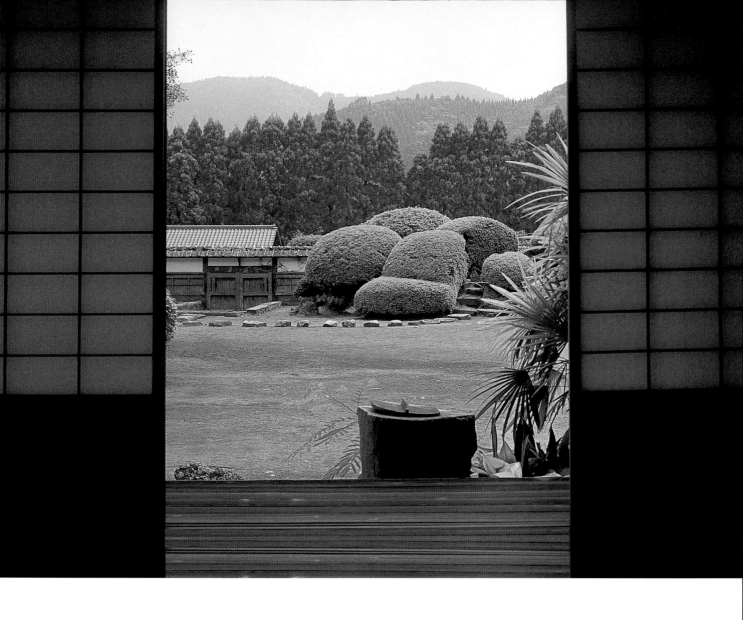

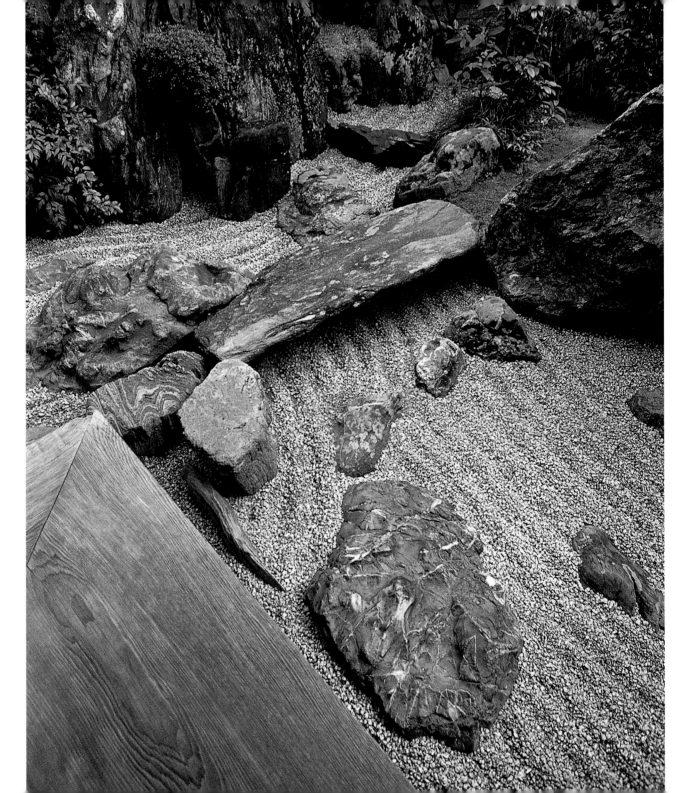

pictorial or sculptural were a host of superimposed and applied concepts, in which Nature was not simply controlled and remodeled, but modified and elevated to reflect the more subtle influences of Taoism, Buddhism, Japanese aesthetics and the new ideas of Zen.

Gardens in the Heian period were expected, like the court, to radiate *miyabi* (grace and refinement), an aesthetic principal that applied as much to garden tastes as it did to personal deportment, court protocol, a knowledge of poetry and dress.

Consciously applied aesthetics of this kind were tempered by a more lugubrious aspect to the culture deriving from the third of the Three Laws of Buddhism: the belief that 2,000 years after the death of the historical Buddha, the world would enter into a period known as *mappo*, the "end of law." This was said to foretell and witness a degeneration of moral and religious mores, one that would lead to social chaos. As this era was believed to have begun in 1052, it is little wonder that a sense of fatalism hung over the Heian court at this time, something that translated into other concepts, inevitably seeping into literature, the arts and gardening.

Mujo (impermanence and evanescence), stemming from the first of the three laws, *shogyo mujo*, declared that "all realms of being are temporary." The indeterminate nature of gravel and sand, materials that require constant maintenance to preserve the patterns raked so ephemerally across their surfaces, readily suggests the Buddhist notion of impermanence, sometimes referred to as the *ukiyo* or "floating world."

> *A dragonfly on the rock;*
> *Midday dreams.*
> Santoka

A heightened awareness of life prefiguring its own demise might be construed as a morbid tendency, but to the Heien period courtiers and those within their immediate sphere of influence, such emotional responses were evidence of a sensitivity to the impermanence of nature, the very beauty and pathos of life. While other religious societies in Asia may have understood this on a metaphysical level, Heian courtiers interpreted such concepts literally. Arson, robbery and the

PAGE 41 The Yoshokan in Obi, Miyazaki Prefecture, is a graceful samurai residence where all the rooms face south in conformity with tradition and the rules of geomancy. Each chamber overlooks a garden with dry landscape features and fine "borrowed views" of Mount Atago.

LEFT Designed by the Zen priest Daisho, Daisen-in is one of Kyoto's most compact gardens. A sea of sand flows down from two vertical stones representing Mount Horai, passes under a stone bridge and around a number of rock islands, before dissipating into a sea of emptiness.

RIGHT Many ornamental touches appear in this private garden from the Edo period. The rocks are numbered into groupings.

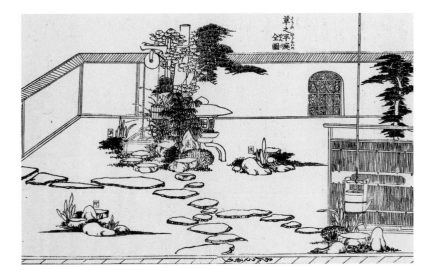

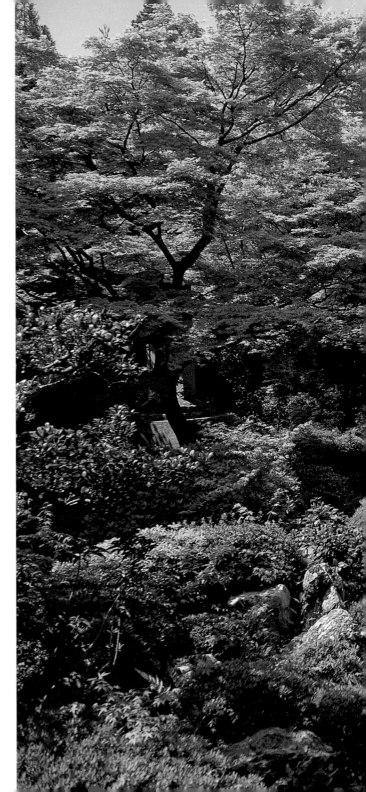

RIGHT Genko-an's rustic setting makes maximum use of the borrowed scenery of Mount Shakadani. Notice the stone turtle island to the right.

ambitions of warrior-priests, all prevalent at this time, seemed to confirm the prophecy.

As power shifted in the Middle Ages from the nobility to a warrior class drawn more and more to the tenets of Zen Buddhism, central posits of Zen aesthetics such as *yugen* (unfathomable depth), *koko* (precious simplicity), *seijaku* (absolute stillness), *ku* (emptiness) and *mu* (nothingness), were absorbed and given consideration in the preliminary stages of designing gardens.

The formative Kamakura period (1185–1333) gave birth to yet another aesthetic, this one called *yohaku-no-bi*, literally "the beauty of extra white." The "white" referred to what should be left out of a painting rather than what is included or applied. Even now, the effect comes across as refreshingly contemporary. Its legacy in garden terms is a frequently encountered expanse of space that allows the viewer to compose or even defer thought until eye contact is made with the garden's principal, often quite modest, features. Reflecting on these concepts, we can more easily understand one important distinction: that stone gardens attempt to transcend nature, not to replicate it.

STONE CLUSTERS

Gardeners appear to have requisitioned the powerful icono-clastic and didactic potential of rocks to enhance gardens, infusing them with meanings that would hold fast within a new religious context. Gardens attached to Zen temples gradually and deliberately assimilated elements that would turn them into incarnations of a Buddhist worldview. This is represented at its least ambiguous in rockwork that represents, for example, stone clusters symbolizing a certain stage in Zen enlightenment.

Buddhist Triad Rocks – *sanzonseki* – clusters of rock representing Mount Sumeru, the mythic center of the Buddhist universe, and arrangements of seven stones representing

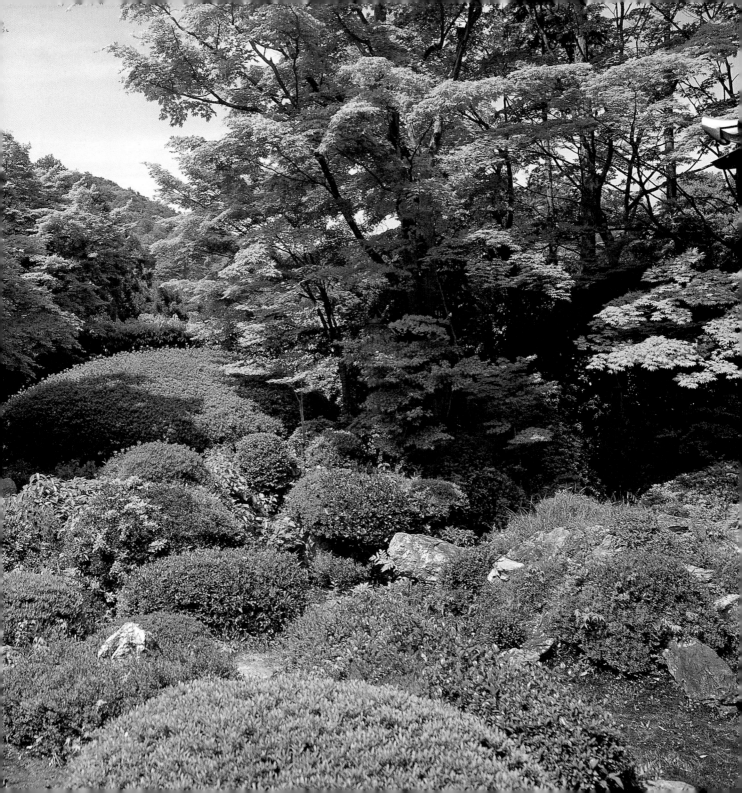

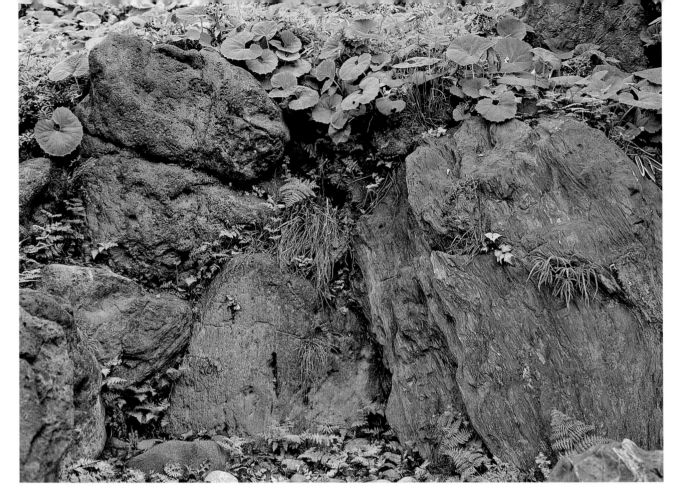

the compassion of the Buddha, are examples of consciously applied concepts. Mount Horai and its rock cluster, the Taoist equivalent of Mount Sumeru, is another common garden arrangement. Although these rock clusters often stand in as a symbol of eternity among the more self-evidently organic elements of a garden, even rocks can be worn down or pulverized. The rock that symbolizes the immutable is not itself indestructible but an icon of something else that is. Stones placed to represent Mount Sumeru stand for fixed elements in the flow and flux of the cosmos. The rock that symbolizes it is more earthbound.

In the fifteenth century, an extraordinary conceptual leap took place as sand and gravel acquired the abstract role

ABOVE The humid Japanese summers and regular rainfall ensure that rocks and other garden materials quickly weather, acquiring a much-appreciated patina of age.

OPPOSITE High-ranking samurai enjoyed rock and bush arrangements, such as this example at the house of Denzaemon Ito in Obi, Miyazaki Prefecture.

of representing water. The transition from natural element to abstract symbolism represents a powerful transmission that is felt even today. Art historian Yoshinobu Yoshinaga, commenting on the appealing contrivances of the *karesansui*, notes that they are "an attempt to represent the innermost essence of water, without actually using water, and to represent it even more profoundly than would be possible with real water."

The Chinese practice of selecting rocks for their fanciful or representational qualities had a degree of influence on Japanese stone gardens, as the renowned boat-shaped rock at the Daisen-in temple in Kyoto and the countless turtle and crane islands of other gardens testify. In general, though, the Japanese have always preferred natural, asymmetrically shaped rocks to fantastically shaped ones, stressing the integration of stones in the overall composition above the strength of an individual rock. Stone clusters are often arranged in naturalistic groups as if to suggest that they shared the same bedrock.

If the Chinese were awed by the elegant perfection of their gardens, the Japanese were more concerned with chance and spontaneity, as seen in the weathering of time, in the darkening of stone surfaces, in the growth of lichen and moss, in the changes in patina and in the seasonal growth of plants, however sparse. The effect is to suggest both time passing and time transfixed.

THE BEAUTY OF AGE

In stone gardens there is a strong sense, even in relatively young gardens, of antiquity and decay. This is perceived as a maturing of the garden, an enhancement rather than a spoiling or erosion. This mood is especially sensed during the humid summer months when the beauties of erosion are seen more vividly in the surfaces of mottled and streaked rocks, stone lanterns and water basins covered in moss and lichen, and in the discoloration of clay walls. The walls on the south and west side of the stone garden of Ryoan-ji are a good example of this elegant simplicity and much-appreciated effect of ageing. The clay used for their construction was boiled in oil. Over time, the oil has seeped through the sur-faces, creating a subdued discoloration.

Traditionally, natural, aged stones have been valued above quarried rocks for their antiquity and refinement. A subdued mellowing, the result of exposure to wind, rain and humidity, can take a long time to develop. The result is a

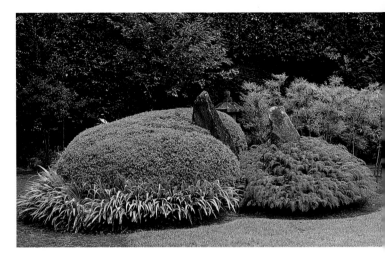

much-cherished aesthetic effect called *wabi-sabi*. The etymology of the expression is revealing, *wabi* stemming from *wabishii* (lonely, wretched), *sabi* from *sabiru* (to age and mature) and *sabishi* (lonely, inconsolable). The compound word suggests a desolate beauty transformed by weathering, the resulting patina of age creating an object or scene of exquisite refinement and taste.

The subject of a deep and complex aesthetic of appreciation, the process is sometimes speeded up by dealers who apply chemicals to the stones and then bury them in the earth to create a "natural" effect of aging and erosion. Similarly, new stone lanterns may be smeared with bird droppings and snail secretions, or rubbed with damp humus and kept in moist, shady areas to achieve the same effects. This is a little like the process resulting in the fabulist rockeries of imperial gardens and classic compositions in cities like Suzhou in China, made from rocks which are submerged in Lake Tai, where over the years they acquire pockmarks and cavities, an effect much to the tastes of Chinese gardeners and viewers. In the case of Japan, this is modified by a quality known as *shibui*, an astringent, unassuming beauty, whereby objects improve with age.

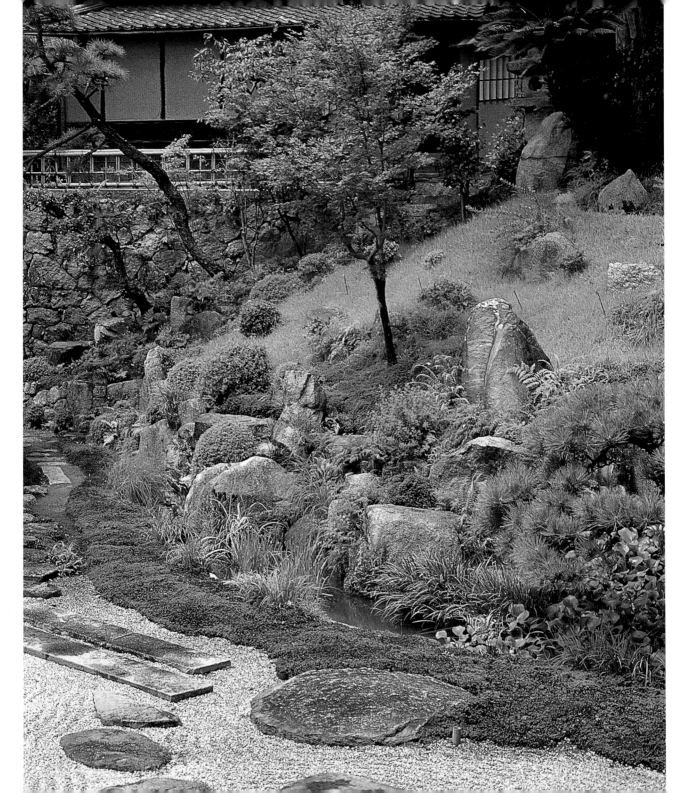

GEOMETRY OF GARDENS

Partly inspired by Chinese landscape painting of the Sung Dynasty, Japanese stone gardens have passed effortlessly into this domain of art, their crisp verticals and horizontals, compositional frame and firmly controlled single field of vision inviting parallels with modern photography. Design sketches and aerial views show how well, how precisely gardens are incorporated into the design of temples, and how seemingly natural forms may be more geometric than first meets the eye.

The arrangement of Horizontal Triad Rocks (*hinbon seki*), for example, is a rock arrangement which, when viewed from above, forms a perfect, flattened triangle. There are very few fault lines in these fusions; the blending is complementary, seamless. This superimposing of natural and rectilinear forms, the sense of beauty that comes from the conjunction of man-made architectural lines and seminatural ones that characterizes so many stone gardens, implies a close affinity with architecture.

The Japanese have tried to unify gardens with temples and homes to create a harmonious environment by projecting the inward outward, by bringing the outside to the inside. Partitioned walls that could be slid open to reveal the garden, and raised verandahs that seem contiguous with the *tatami* mats of the inner rooms, are ways to achieve this. During the Heian period, scrolls depicting mountain scenes were hung in room alcoves, replicating the miniature landscapes created in the adjacent garden.

The co-existence of the right angle, its planar severity, with the random forms of nature, characterize the traditional Japanese garden. In the stone garden, this is seen in the interaction between the man-made geometry of viewing porches, stone and tile borders, the enclosing walls of the garden and natural rock formations. Complete geometric forms like squares and circles are sparingly applied, usually only for the purposes of contrast or to replicate the lines of a building close at hand.

OPPOSITE The little-visited dry landscape of Misho-teien, part of Jodo-ji Temple in Onomichi, Hiroshima Prefecture, dates from around 1806.

ABOVE This *noren* curtain, often found outside Japanese restaurants and tea houses, resembles the Taoist divided circle or "diagram of the supreme ultimate."

Being modular, stone gardens are well suited to be viewed in the open or against the grid of a paper-screened door or the planar geometry of *tatami* mats. If this implies a perfectly symmetrical world, though, this is not the case.

Balanced asymmetry, the use of the triad form, defines one of the differences between Western and Japanese gardens in general. In the stone garden, an arrangement viewed from a fixed architectural position, there is a deliberate scrambling of symmetry so that, while a hierarchy may exist, no one form dominates. The mind, instead, is encouraged to move at random from one feature to another. An axial relationship centered on a single focal point is eschewed in favor of triangular forms and odd numbers.

> *... if a Buddhist Trinity is placed in the southwest, there will be no curse, neither will devils be able to enter.*
> Sakutei-ki

The Buddhist triad (*sanzonseki*), an arrangement of scalene triangles, with the central stone representing the Buddha and the two flanking stones epitomizing his attendants (*bosatsu*), is the most obvious embodiment of this structural principal of the stone garden. Placed along a northeast–southwest diagonal favored by malign spirits, the original idea of the grouping was to snare these forces and, with the aid of south- and west-facing stones, to deflect them, thereby protecting the garden and house.

Reciprocity exists within these symbiotic groupings of rocks and ornaments. The relationship between the *chozubachii*, a water laver sometimes placed at the side or corner of the garden or in the background arrangement, creates a triangular form. More subtle still are the intersections of horizontal, vertical and diagonal forms representing heaven, earth and man, achieved by the use of rock forms to create a triangularity that is found in other Japanese arts such as bonsai and flower arrangement. Embodiments of odd numbers (*kichijyosu*) are auspicious, especially three, which represents heaven, earth and humanity. Because they are not evenly divisible, odd numbers are thought to defy the notion of completion, aligning the garden closer to a natural wilderness.

Layered horizontal lines are used to expand space. Another device is to place small objects in the background to create a sense of depth and larger objects in the foreground, while other objects are positioned across the garden's diagonals, again enhancing the effect of distance. As diagonal lines are naturally dynamic, this also succeeds in creating a visual tension that energizes the gardens.

ALTERED PERSPECTIVE

The interplay between planes represented by flat stones, raked sand and walls and the volume and mass of topiary and rocks seen in stone gardens of the medieval period, highlights one of the most fundamental design concepts of the Japanese garden. Many stone arrangements incorporate elements of the gardening

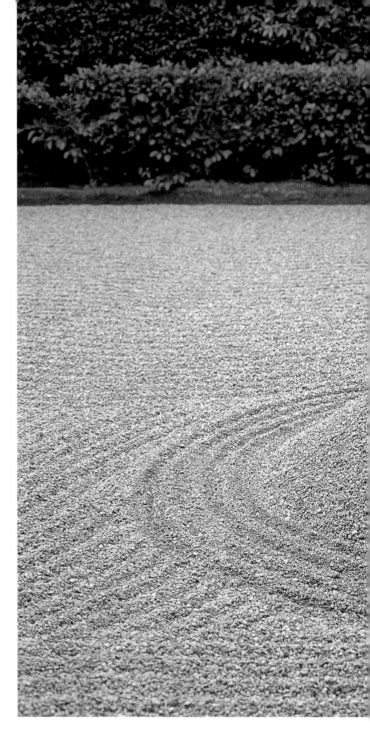

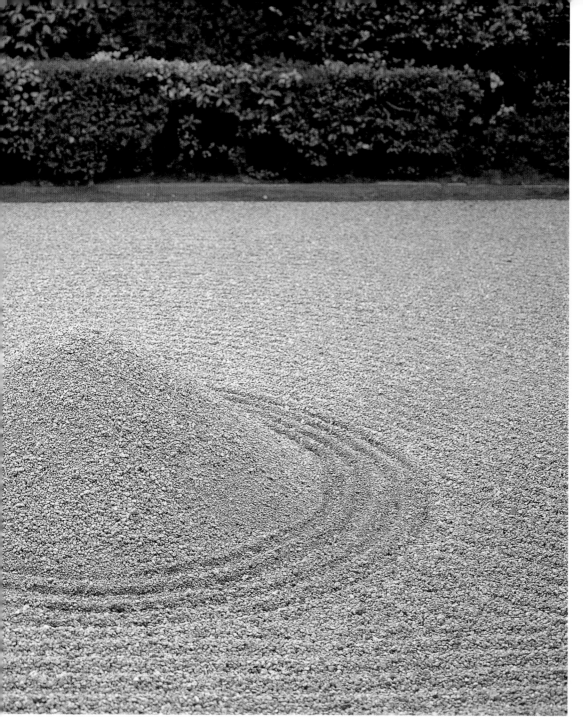

LEFT Two mounds of sand at Daisen-in Temple, known as *kiyome-no-mori*, symbolize purity.

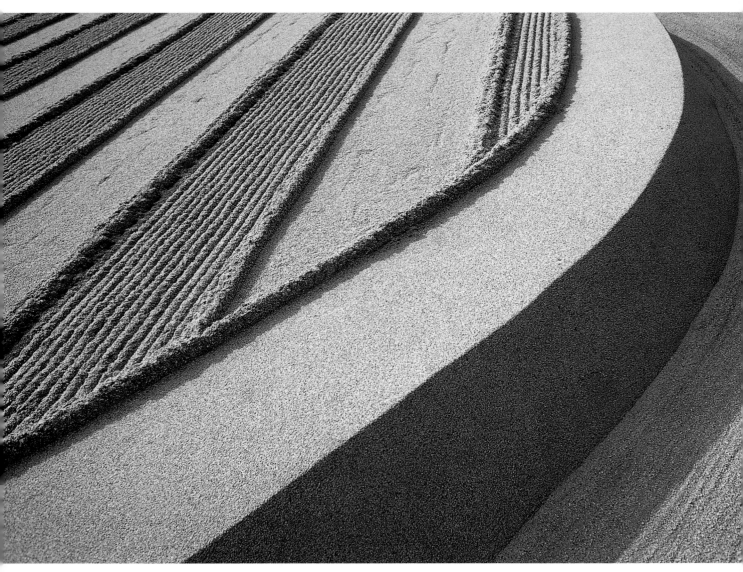

ABOVE The Sea of Silver Sand at the Ginkaku-ji Temple is named after its enchanting moonlight appearance. Damage caused by weather, wild boars and other animals from the hills behind the temple that move through the garden at night, means the bed of sand has to be remade every month.

style known as *hira-niwa* ("flat garden") into the overall geo-metrics. Balance is achieved in a variety of ways: through the division of the ground plane, and the use of walls, hedges and fences to frame, layer and add depth of field to the garden.

These planar devices are placed against volumetric, three-dimensional forms such as topiary, stones and orna-mental features like water basins to achieve counterbalance and compositional unity. The almost cubist effect of tightly composed planes and volumes at its most sublime in the dry landscape garden may explain why centuries-old gardens appear to be modern to the contemporary eye.

Framing is an essential consideration of the Japanese garden, as important as in painting. The frame turns the garden into art. One simple technique in restricting or manipu-lating space is altered perspective. If large rocks are placed in the foreground and smaller ones in the background, other objects positioned across the garden's diagonals, for example, the result is an illusion of distance and depth. As diagonal lines are naturally dynamic, this also succeeds in creating a visual tension that energizes the garden.

Stone gardens are usually viewed from a fixed position along one of the verandahs that border them. There are some exceptions, however. Old prints of the Ryoan-ji garden show visitors standing on the gravel inspecting the stones or engaged in conversation. Likewise, the small *karesansui* attached to samurai villas at Chiran are generally viewed from inside the design rather than from their raised wooden verandahs. At Senshukaku Teien, a garden in Tokushima, visitors appear to wander freely, even taking the liberty of walking along the top of its stone bridge, said to be the longest in Japan.

Unifying a distant view with foreground, a technique known as *shakkei* ("borrowed view") is also sometimes used in the dry garden. Originally, the device was used in the design of Muromachi period Zen temples, where ten features of the sur-rounding landscape were imbued with names that contained a Buddhist meaning or message. Gradually, the environs were drawn into the religious and doctrinal sphere of the temple.

Garden designers co-opted the method of *shakkei* so that any number of images, from a ridge of trees to a tiled rooftop to the outline of a sacred mountain could be incor-porated into the composition of the garden itself. The recon-structed garden at Tenryu-ji in Kyoto, designed by Muso Soseki, is the earliest known example of the method. The middle distance is the key to the success of the *shakkei* effect, drawing the far distant view closer, causing it to appear larger than it really is. At the same time, the foreground stretches and deepens to meet the distant view, the entire effect creating a convincing illusion of space. The success of the device, however, depends on the absence of any distracting elements such as overhead wires or new buildings, a condition that is becoming increasingly difficult to satisfy.

A measure of how far Japanese garden design principals had advanced since earlier borrowings from China can be seen in a 1634 Chinese publication called *Yuan ye* (The Manual of Garden Design), in which the painter and garden builder Ji Cheng, echoing a concept long applied in Japan, holds that the skill in landscape design "is sown in the ability to 'follow' the lie of the land and 'borrow from' the existing scenery." A garden, in Ji's estimate, acquires a relationship to the envir-onment only when it borrows scenery that exists beyond the confines of its own walls.

The gardens may appear to reduce, to diminish the temporal, to stop the heart of time, but they are living spaces that depend, ultimately, more on beauty, sensory effects and intuition than on explanation. Straining to conceptualize gardens can be a peculiarly counter-productive endeavor, one that can diminish their intended effect and the sheer pleasure to be had from viewing them. It is more liberating, perhaps, to view successful gardens as works of art in their own right, aesthetic accomplishments or architectural com-plements to contiguous structures. The Japanese genius for garden design, seen in these and other forms, is expressed in the seamless blending of art and nature through an extra-ordinary economy of means; everything in its ordained place.

Chapter 4

JAPANESE GARDEN DESIGN ELEMENTS

Stone gardens are said to be at their best after a light rainfall or when water has been poured over stones from a wooden dipper. When it rains, even just a light summer shower, plants on the fringes of gardens are engorged, moss swells into a spongy richness, sand and gravel seem to stir with life. A mineral smell of raw geology impregnates the air. Light, tone, a change in air currents, the garden is forever changing.

Gardens may have acquired some of the features of natural evolution through the accretions of age, but stone gardens, mindfully concerned with their own design, are hardly naturalistic. While characterizing *karesansui* as contemplation gardens, the more earthy side to their creation, the physical properties of rock, sand and gravel, should not be neglected.

Natural garden stones are found in riverbeds, valleys, mountains, marshes and seashores or are unearthed from construction sites. These are classified for convenience rather than accuracy as mountain, lowland, river and seacoast stones, and comprise *suisei-gan* (sedimentary rocks) of a smooth,

water-worn variety; roughly textured *kasei-gan* (igneous rocks), the product of volcanic activity; and *hensei-gan* (metamorphic rocks), which tend to be of a very hard texture.

Japan has not been shaped to the same degree as China by the erosive forces of wind and water. Geologically younger, still racked by active volcanoes, igneous stones like granite (*mikage ishi*), chlorite schist (*ao ishi*), slate, pumice, marble, volcanic tuft and basalts dominate over sedimentary rocks.

Traditionally, black or white stones were not used in these gardens except as cobblestones or pebbles. Nor were combinations of strongly contrasting colors, Japanese tastes tending toward earth hues such as gray, russet and green-blue, or the streaked, flinty, flat-topped rocks on which Zen monks would sit to meditate. Only certain types of stones are used for the more accomplished gardens. These should be hard enough to endure weather conditions without disintegrating, have interesting "character" surfaces and, at times, small crevices and broken veins so that moss can find an easy footing.

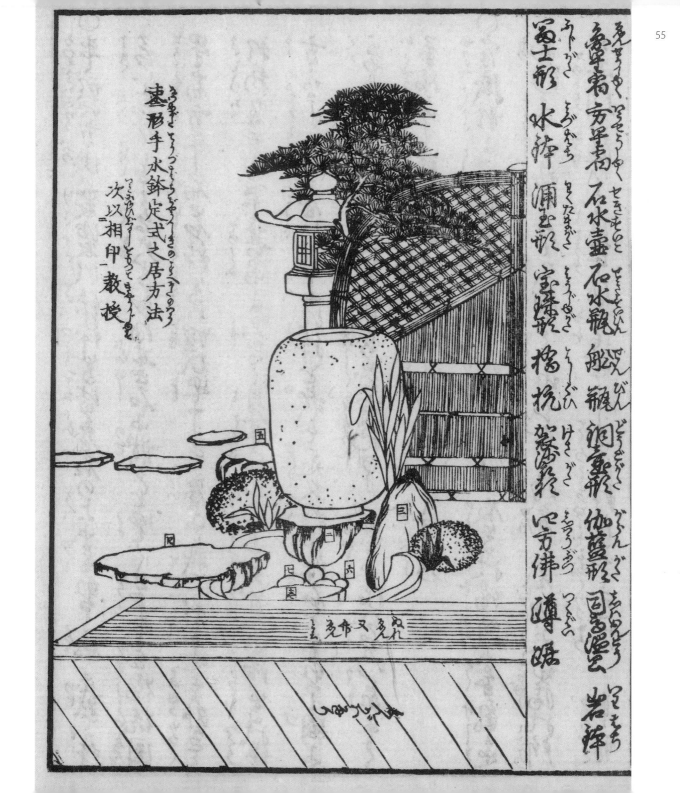

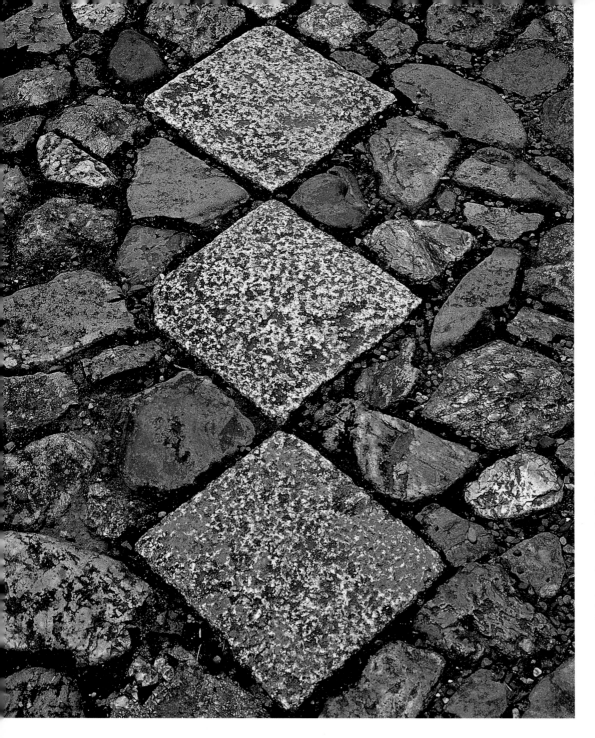

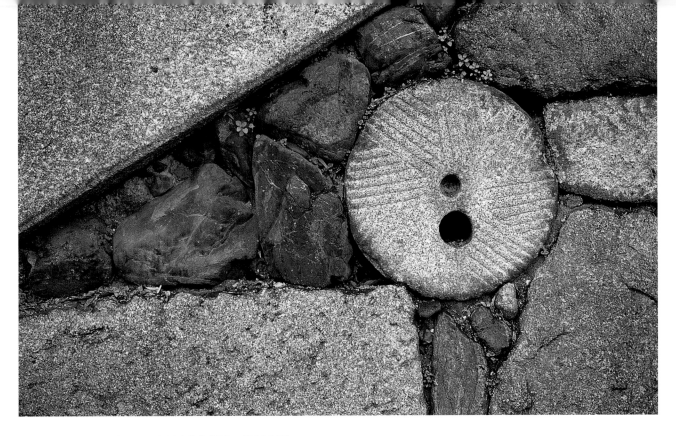

NATURAL STONE, QUARRIED STONE

The mountains near Kyoto are rich in beautiful stones, which have been treasured as garden materials since ancient times. However, a reduced supply of natural stone in recent years, especially the weathered variety favored by traditionalists, combined with the influences from new styles of architecture, has led to the widespread use of processed stone, quarried and cut and with the surfaces sometimes polished. Synthetic materials, long held at bay, have finally entered modern gardens in the form of cement, plastic, steel, metal and even carbon fiber trimmings.

Kiirishi (cut rocks), traditionally used for making ornamental features such as lanterns, bridges and water basins, are also used as rocks in contemporary gardens. A variety of methods, including polishing, the application of matte lacquer, grinding and acid burning are used to alter the surface and color of stone.

Purists maintain that only stones in their natural form should be used. Landscape gardener and writer Erik Borja holds that "Under no circumstances should quarried stones be used in a Zen garden because the process of extracting them from the ground reduces them to the level of debris, with no sheen or soul." Others would argue that from raw matter, exquisite sculptural forms can be fashioned in both the spirit of Zen, nature and the soul/personality of the artist or stonecutter.

STONE FEATURES

Although purists still insist that the artificiality of hewn stone is antithetical to the Japanese garden, stone-worked objects were introduced into the garden as early as the Muromachi period (1333–1568) in the form of stepping stones, water basins and stone lanterns and stupas. The requisitioning of gardens for ornamental or talismanic purposes continued in the Edo period (1600–1868), with the placing of *ying–yang* rocks, resembling

the male and female organs in gardens as symbols of fertility. A fief would automatically revert to the local *daimyo* or feudal lord should a warrior die without a male heir.

Granite bridge piers were often requisitioned to make *chozubachi* (water lavers), which were also made from natural sculptured stones taken from riverbeds and seashores and then carved into a clean and precise form. These hand basins were originally placed outside Shinto shrines so that pilgrims could wash and purify themselves before worship. *Tsukubai*, stone water basins that also include a lower arrangement of attendant stones, though more commonly found in tea gardens, are also features of the *karesansui*.

The first stone slab bridges used in Japan were set over rivers of sand in miniature landscapes like that at Daisen-in. Statues representing *arhats*, disciples of the Buddha, are often depicted sitting in front of or among stones, echoing the images found in paintings where Zen monks and patriarchs are seen meditating in caves, in front of cliffs or seated serenely on rock pedestals.

Black pebbles, known as *nachiguro*, are often used to create narrow strips called *inu-bashiri* along walls or under the eaves of temples and villas. Besides their aesthetic appeal, especially after rainfall, they have a practical function, helping prevent the runoff from rain inundating the garden itself. Flat tiles bordered by narrow strips of granite are sometimes placed at the edge of the sand to form a similar walkway for monks. Black tiles, requisitioned from temple roofs, are often placed in an upright position to form a border between pebbles and the main garden. A similar function applies to dry streambeds, which can provide drainage for garden runoffs.

BELOW LEFT A *tsukubai* (water basin) at the seventeenth-century Keishun-in, a small and rustic sub-temple within Kyoto's great Myoshin-ji complex.

BELOW RIGHT This stone path at Tenju-an in Kyoto was built in 1338, a year after the temple was erected. It survived the destruction of the buildings during the Onin War (1467–77) in central Kyoto.

RIGHT A modern garden arrangement near the entrance to Myoren-ji, a quiet temple in the Nishijin district of Kyoto.

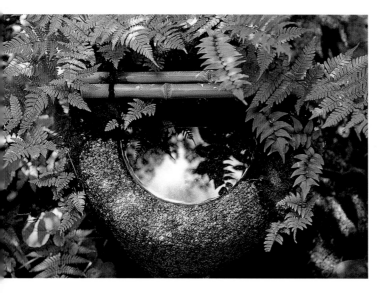

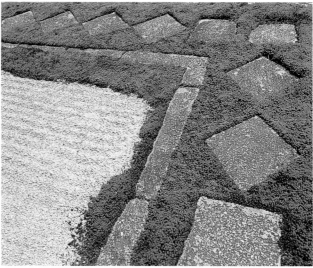

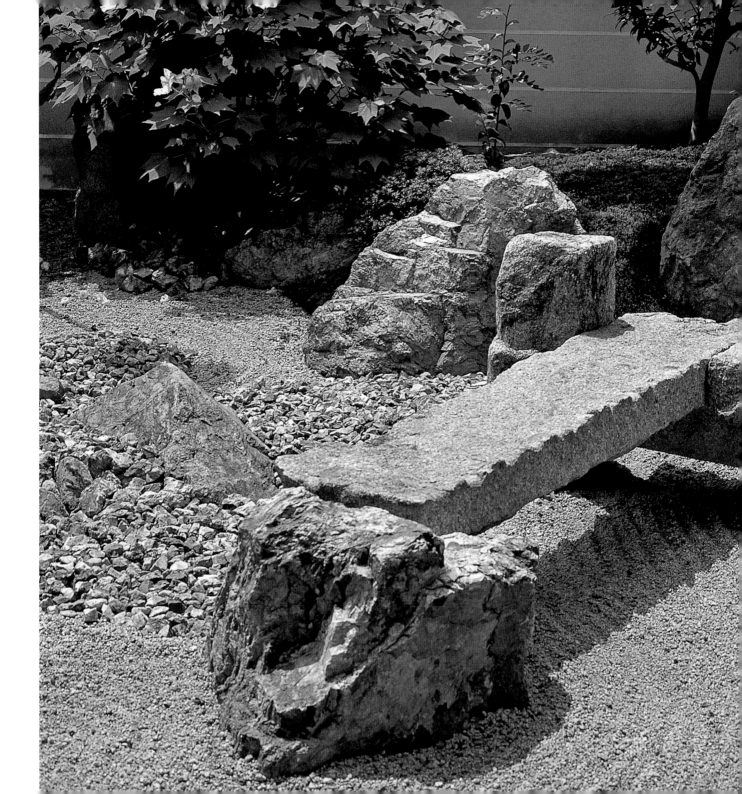

ABOVE A water-fed bamboo "deer-scarer" produces clacking sounds pleasing to the ear.

BELOW A bed of blue-gray stones at Hogonin Temple in Kyoto creates a strong contrast to the moss surrounding the stones.

While Tokyo produces some of Japan's finest colored sand, the Kyoto region is blessed with an abundance of white sand. The eastern range of hills, known as Higashi-yama, are made of a white granite composed of gray quartz, black mica and white feldstar. With exposure to the elements, granite is reduced to a grainy sand called *masago*, which then runs into local rivers and streams. The principal river exiting these hills is the Shira-kawa (White River), and the sand it deposits is known as *shira-kawa-suna* (Shira-kawa sand). Surrounded by hills rather than cliff or craggy coastal landscapes, there is an abundance of *suhama* (gravel seashores) and *ariso* (rock-strewn beaches) in the city. Some contemporary garden designers use pieces of cut stone for garden surfaces, their quarried look allowing for greater diversity in scale and form.

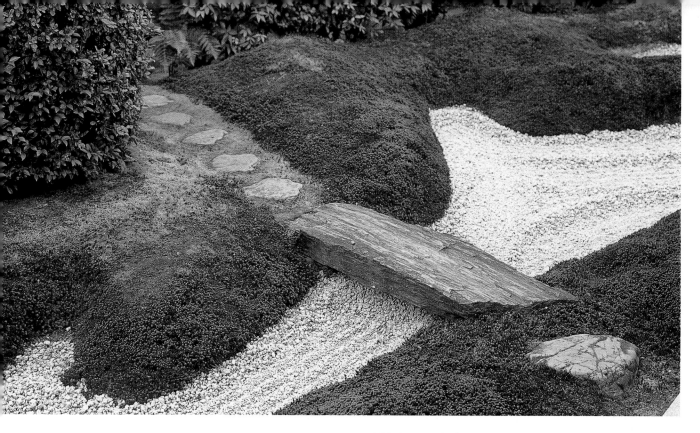

ABOVE A stone bridge crosses a river of gravel at Zuiho-in, a sub-temple of the large Daitoku-ji complex.

PLANTINGS

Much is written about Japan's culture of impermanence, but many stone garden designs have endured for centuries, allowing the original work and intentions of the designer to achieve a more lasting legacy. Conversely, any shortcomings in the design will also endure. Unlike European gardens which, beside ornamentation, rely almost entirely on perishable plantings, the dry landscape garden, composed of rocks, replaceable sand, gravel and clay, has more chance of surviving the violence of nature than a garden composed mainly of plantings. Stone gardens are designed whole and complete and are not expected, like Western gardens composed of mostly organic matter, to change significantly over the years. In earthquake-prone Japan, stone gardens have fared far better than buildings.

The perennials and flowering shrubs of other Japanese garden forms are restricted in the stone garden to a limited palette of mostly green shrubbery, trees such as pine and maple, and hedges, although there are occasional splashes of camellia, peony and Chinese bellflower in the less severe dry landscapes. Azaleas are used as they can be trimmed into the shapes of clouds, waves, mounds and mountains. The Japanese holly, with its small evergreen leaves, also lends itself to topiary designs, especially the "cloud style" so popular in Japanese gardens.

Camellias, whose flowers may fall in mid-bloom, are sometimes incorporated into gardens to suggest the frailty and uncertainty of life. Moss growing on the north sides of rocks conveys calm and quietude, a sense of warmth and ageing, softening some of the harder features of the garden.

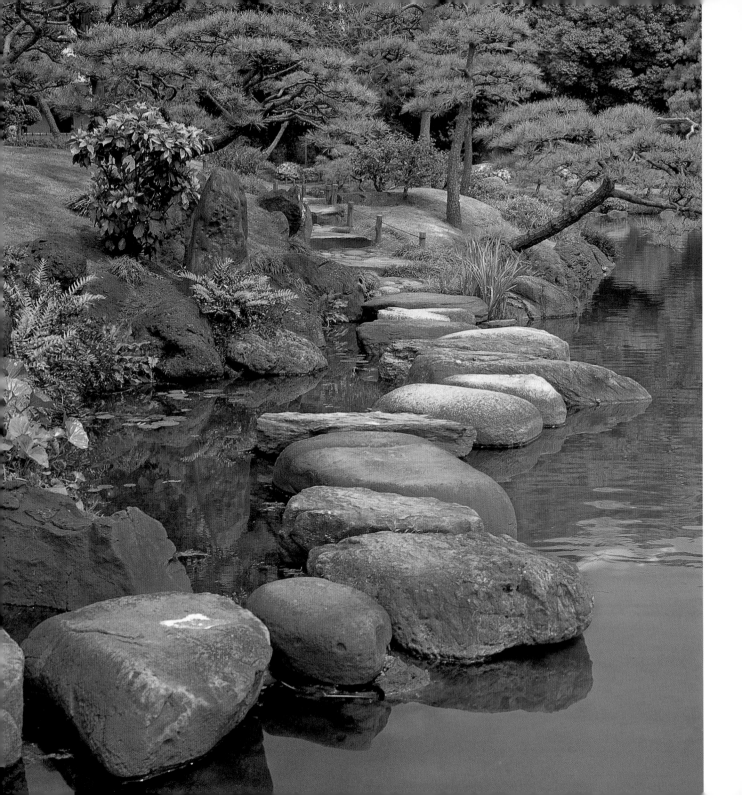

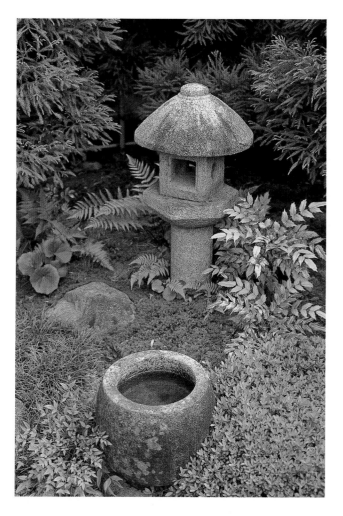

Along with ferns and fatsia (*yatsude*), moss evokes the feeling of a forest floor or glade. The dark green of acers, aspidistra, sasanqua and hosta are sometimes planted near the base of rocks to suggest a verdant coastline.

By means of microscopic observation and astronomical projection, the lotus flower can become the foundation for an entire theory of the universe and an agent whereby we may perceive Truth.

Yukio Mishima, *The Priest And His Love*

In the small number of *karesansui* that have actual rather than abstract ponds, lotus are generally preferred to the water lilies and water hyacinth found elsewhere. Pleasing to the eye, with roots and pods that are edible, the lotus is also a symbol of Buddhism. Rooted in mud, the lotus rises to the surface of the water where it produces a flower of heart-stopping beauty. Buddhists hope that they, too, can rise above the impurities of life and attain enlightenment, an idea echoed in countless statues of the Buddha seated on a dais of lotus blossoms. This most exotic of Eastern plants, its blossom pink and fleshy between floating divans of green leaf is, moreover, explicitly voluptuous, evoking the "jewel in the lotus" of the sutras.

THE VALUE OF STONES

Except in all but the most revered gardens, specifically those that have become official national treasures, gardens tend to undergo periodic changes. Stones only very rarely remain within the same garden. As private gardens and houses are sold or demolished and temples are altered, stones, together with lanterns, water basins and even plants, are disposed of to people in the trade who then place them elsewhere. Although stone gardens may give the impression of time-lessness and permanency, in reality they contain the elements of a portable culture. In the case of Zen temples, materials are often donated so that the stones, gates and timbers of one temple may well resurface in another.

LEFT Though not a stone garden, rocks are an important element in Tokyo's Kiyosumi-teien. When the garden was restored in 1878, its owner, the wealthy industrialist Yataro Iwasaki, had rare and well-formed stones shipped from all over the country to Tokyo in his company's steamships.

ABOVE Water basins and stone lanterns surrounded by moss and low plantings are common elements in gardens.

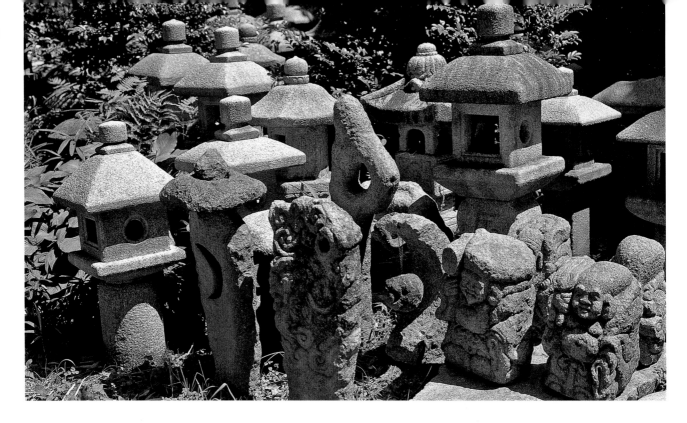

ABOVE Stone lanterns and other garden objects in a stone yard in Kyoto.

RIGHT Skillfully placed within gardens, stone, bamboo, tile and gravel can be surprisingly harmonious materials.

Traditionally, stones were always *objets trouve*, never quarried, cut or polished. The originators of the tea garden, however, introduced the idea of placing objects in a new context that would give them and the garden a fresh dynamism. This idea, known as *mitate*, is seen in the use of recycled temple and villa foundation and pillar stones and the use of millstones taken from demolished buildings. These *ishi usu*, round, flat-surfaced stones with blunt, serrated radials on the surface, were often used on farms as kitchen boards to wash, prepare and cut vegetables. These have now found their way into gardens as ornaments, accents in an otherwise flat surface of sand. Temple roof tiles (*kawara*) are also commonly used as borders or embedded in clay walls known as *neribei*.

The gardens at Tofuku-ji in Kyoto skillfully incorporate a number of *mitate-mono* or recycled or requisitioned materials. The northern garden here has a checkerboard pattern design made from cedar moss and sunken squares of stone once used as an entrance path. The eastern garden has an arresting design employing seven cylindrical stones set in white gravel, composed in the shape of the Big Dipper constellation. The stones were once used as supports for the temple's latrine.

Distinctive stones bearing unique features have always been costly. After looting the gardens of vanquished enemies, soldiers in the service of the sixteenth-century warlord Toyotomi Hideyoshi would send the best stones back to the generalisimo wrapped in silk. An earlier warlord, Oda Nobunaga, recognized the value of stones, exchanging in one incident a miniature landscape stone, along with a treasured tea bowl, for the strategically important Ishiyama Castle.

The longer the rock's pedigree and the stronger its historical associations, the more valuable it will be. If a rock has, for example, been referred to in a poem or featured in a painting, or has sat within the garden of a renowned artist, court official or nobleman, its stock will have risen. Rocks often form part of a family inheritance and will be passed down through the generations.

ABOVE This large *chozubachi* (water laver) has become a powerful visual element in this garden.

RIGHT The landscape design at Ninna-ji Temple in Kyoto represents interesting transitions from paradise and stroll gardens to the Zen model for the contemplation garden.

Because stones have always been associated with the eternal and the ageless, a ceremony, practiced until seventy or eighty years ago, used to be held between clients and gardeners in Kyoto. Oxen were used to carry stones from valleys to the north, a process that was conducted at night when the drover could bring his cart safely through the narrow streets of the city. As the cart approached the client's home, just before dawn, the master and mistress of the house and other family members would be waiting at the gate, where a brief reception party was held, in which food and saké were shared between client, gardener and laborers, an event that symbolized an agreement between both parties to collaborate on making a fine garden.

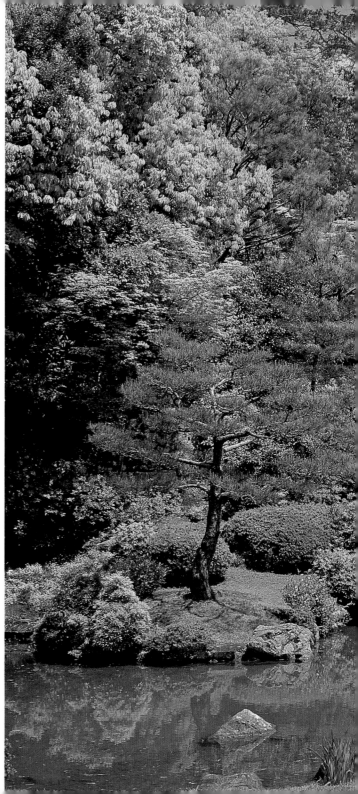

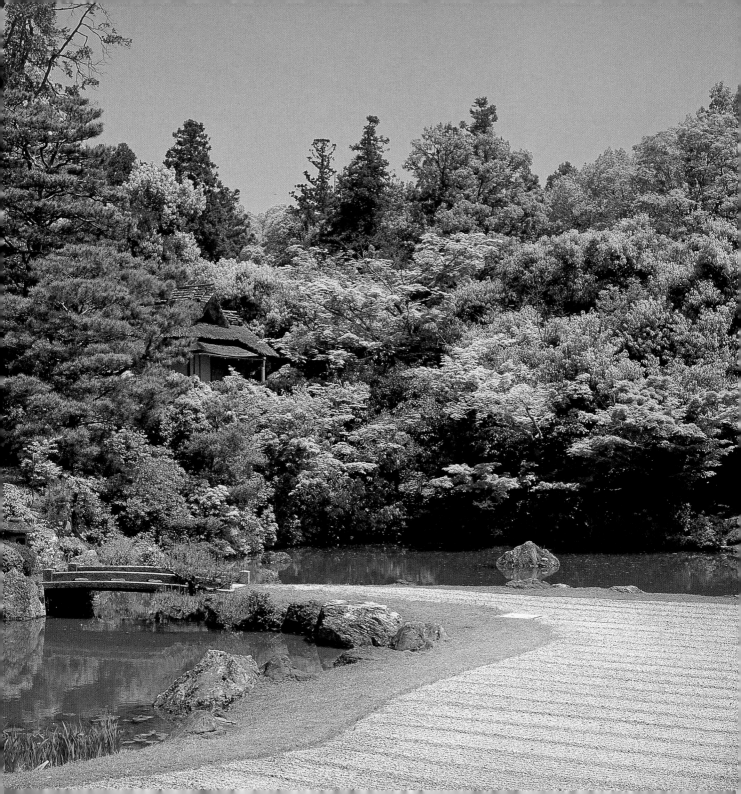

68

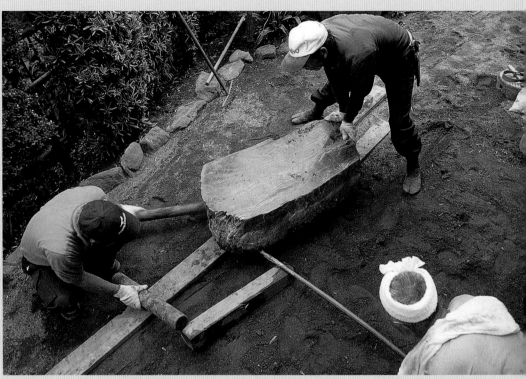

ABOVE Sprinkling water over the Sea of Silver Sand at the Ginkaku-ji Temple after it is rebuilt helps to keep the mass in place.

ABOVE Moving a heavy stone in a private garden by traditional methods, using wood rollers, planks and plenty of muscle.

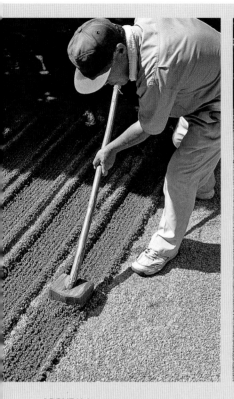

ABOVE Using a narrow sand-ripple rake to create lines.

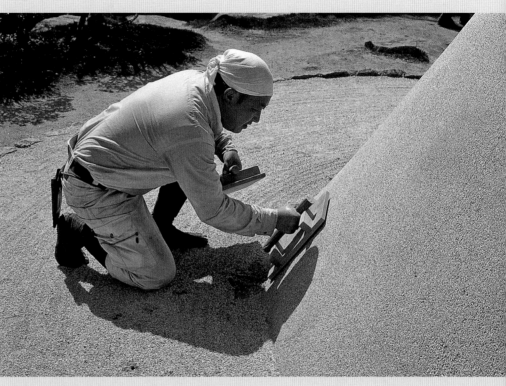

ABOVE A gardener at Ginkaku-ji Temple evens the sides of its famous truncated cone using a flattening board.

Chapter 5

MODERN JAPANESE STONE GARDENS

A revival of interest in the dry landscape

garden, both domestically and internationally, took place during the early Showa period (1926–89), in which abstraction and symbolism once again came to the fore.

This was partly due to the fact that several new temple gardens were commissioned at this time, but also to the efforts of a number of prominent garden designers, among them Kinsaku Nakane and Tono Takuma. The writings of Daisetz Teitaro Suzuki, a Buddhist philosopher and teacher, and garden books by the American Lorraine Kuck, are also associated with the "rediscovery" of stone-and-sand gardens and their linking in the mind with Zen principals.

Arguably, the foremost figure in the renaissance of the dry landscape garden was designer and garden historian Mirei Shigemori (1896–1975). Shigemori believed that by the middle of the Edo period, as professionals took over the construction of Japanese gardens, much of the vitality had been leached out of them, and that emulation and repetition

had replaced innovation. After a survey of almost 250 gardens throughout Japan, a colossal undertaking, Shigemori took on the mission of renewing the Japanese garden, in particular the stone garden.

Shigemori's concern to reinvigorate the Japanese garden resulted in innovations, the like of which the Japanese design world had rarely seen. Like all radical shifts, though, this one deeply divided the garden establishment. It is a testament to the originality of Shigemori's work that it still does.

Those who embraced Shigemori's avant-garde designs admired the conceptual leaps seen, for example, in gardens rigged with lassoes of twisting line representing waves or clouds, and in his use of sand and gravel, often colored and raked into curlicues or cross-hatched, complementing the fresh geometric forms of the garden.

Most controversial, perhaps, was the use of concrete, something vigorously opposed by purists. Shigemori's favorite stone was *ao ishi*, a kind of blue or greenish chlorite schist

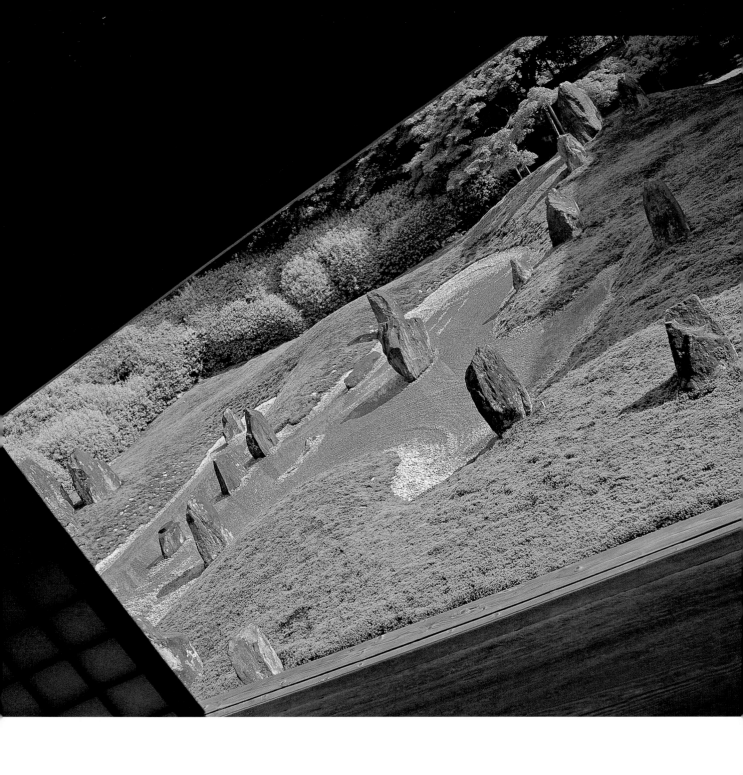

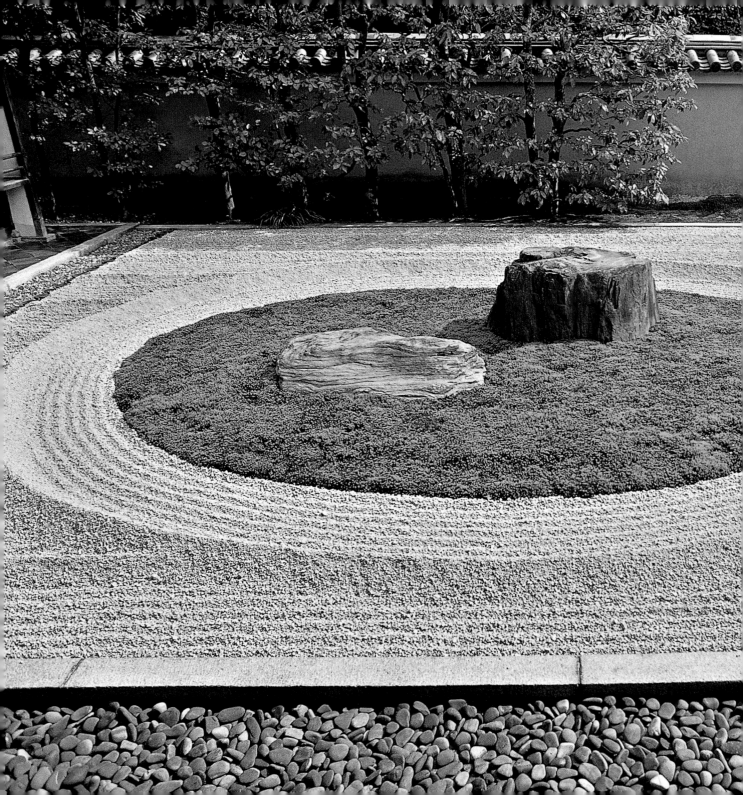

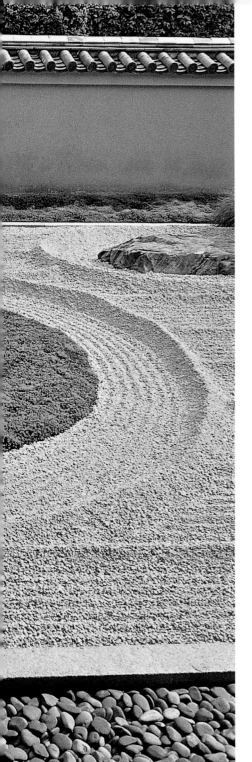

PAGE 71 At Komyo-in, a sub-temple of Tofuju-ji, Mirei Shigemori created a curvaceous garden transected by rocks placed in lines to represent rays of light emitting from three stone triads positioned at equidistant points.

LEFT One of five gardens at Ryogen-in, the Isshidan was partially reconstructed in 1980. While retain-ing traditional fea-tures such as the central Tortoise Island, the project imbued the garden with crisp, modern lines.

commonly used in the rather overstated gardens built for Japan's nouveaux riches in the 1960s and 1970s. Other rocks are coal-dust or kidney-colored.

Shigemori liberated the stone garden in a number of other ways. His 1972 stone garden at Sekizo-ji Temple in Hyogo Prefecture was highly innovative in its use of four different colors of gravel instead of the usual one. The interlocking rectangles represent the Chinese notion of the *shisin soo*, the four gods whose function it is to protect the four heavenly directions. In this garden, the ideograms that make up the word *shisin* are written in bamboo across the garden fence, another highly original touch.

The talented designer was probably also the first to suggest using stone gardens as performance and exhibition spaces. Shortly after the completion of Shigemori's *karesansui* at Kishiwada Castle, an exhibition of metal sculptures was mounted in the garden. In keeping with his personal contri-bution to the stone garden, Shigemori produced a traditional dance performance for the event in which the theme was the straight and the curved line. In his mind, there was no reason a garden should not be multifunctional.

Shigemori even placed stone gardens within the precincts of shrines, a practice that may have appeared radical at the time but was in a sense an acknowledgement of the ancient links between gravel-laid forest clearings for the gods and early Shinto's connection to rocks, stones and the use of sand. A good example is his design for Sumiyoshi Shrine in Hyogo Prefecture, although the garden now appears to be in need of some maintenance to its splintering bamboo fences, crumbling borders and signature white cement lines that flow through the garden like thick pythons, the concrete surfaces cracked and scaly, unintentionally heightening the serpent analogy.

Reiun-in, a sub-temple of Tofuku-ji, was reconstructed by Shigemori in 1970. The garden is another example of the risks involved in using modern, perishable materials. The red paint once mixed into daring flourishes of cement has long faded, and the material is fast turning to building rubble. A corroded,

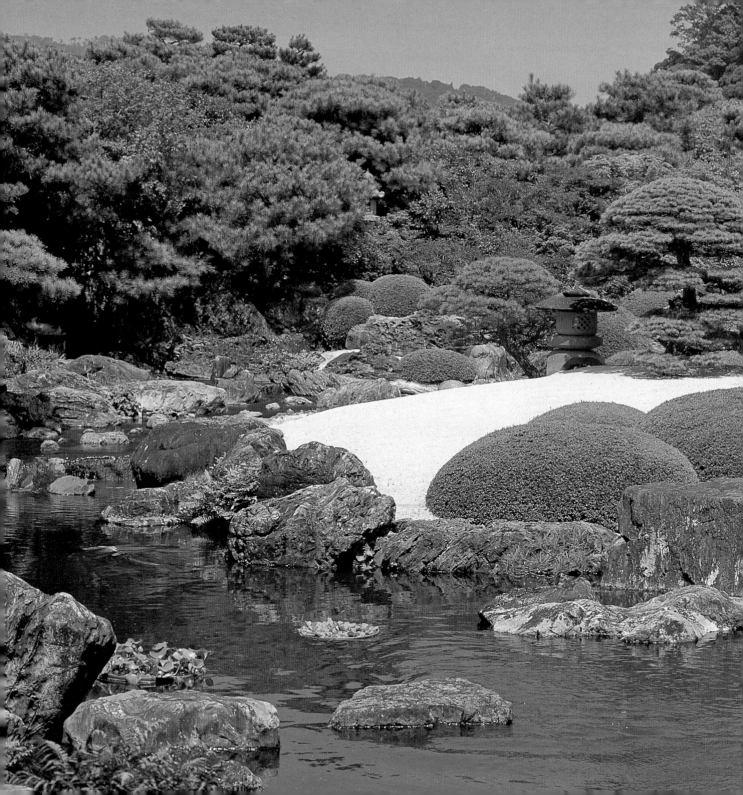

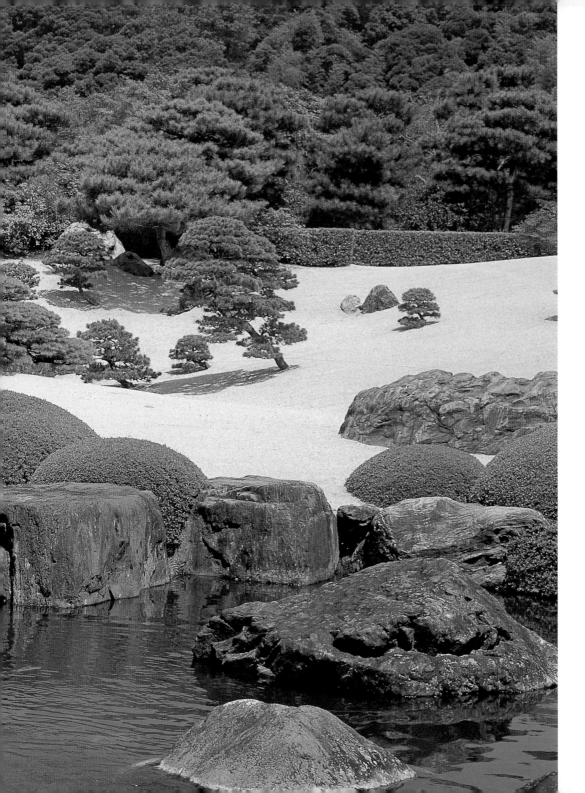

LEFT Designed by Kinsaku Nakane in 1970, the Adachi Museum garden in Shimane Prefecture combines a large-scale dry landscape with highly naturalistic features.

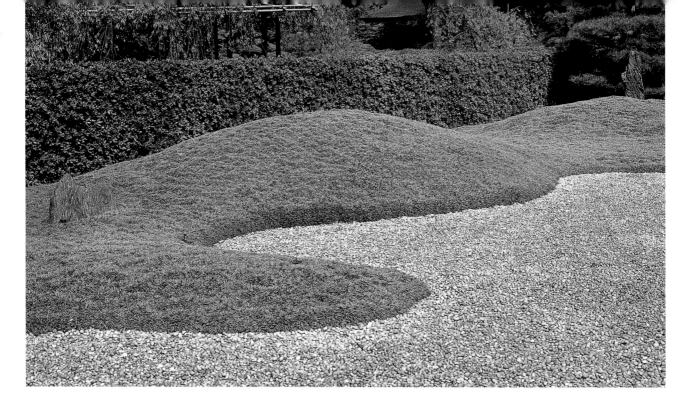

deeply stained *suiseki* stone arrangement supported on a concrete structure resembling a stone lantern at the center of the garden looks like an ashtray or old mortuary tablet.

Ultimately, an appreciation of Shigemori's work is a matter of taste, but the gardens are always alert and refreshing, a "compelling manifesto" as landscape designer Christian Tschumi has written, "for continuous cultural renewal." Only time will tell whether Shigemori's works will live up to his own criteria for permanence.

SPATIAL SCULPTURE, ART INSTALLATIONS

Thanks to the daring of landscape designers like Shigemori, we can now glimpse the application of gardens not only as adjuncts to temples, samurai villas and private estates but as components of hotel complexes, research centers, corporate headquarters, government buildings, hotels, even bridal halls. Greater freedom in the interpretation and use

ABOVE The last and most abstract of five linked gardens at Jonangu Shrine, Kyoto, was designed by Kinsaku Nakane.

RIGHT Isao Yoshikawa's contemporary design at Komyo-ji Temple in Kamakura uses blue crystalline schist stone. The larger of the three central stones represents Amida Buddha crossing the mountains. Two bodhisattvas, Kannon and Seishi, are in attendance.

of traditional materials and design concepts have led to new stone compositions, reminding us that, while there are design principals, the Japanese garden is a free form of art.

The practice of cutting rocks to fit a preconceived design, common in the postwar period, has meant that the arrangements now commonly seen in hotel lobbies and public plazas, at the entrances to government offices and corporate headquarters, are often indistinguishable from sculpture. Kenzo Tange's stone and pond garden, designed for the Kagawa Prefectural Government offices in 1958, is an early example of the dovetailing of architecture and stone garden design.

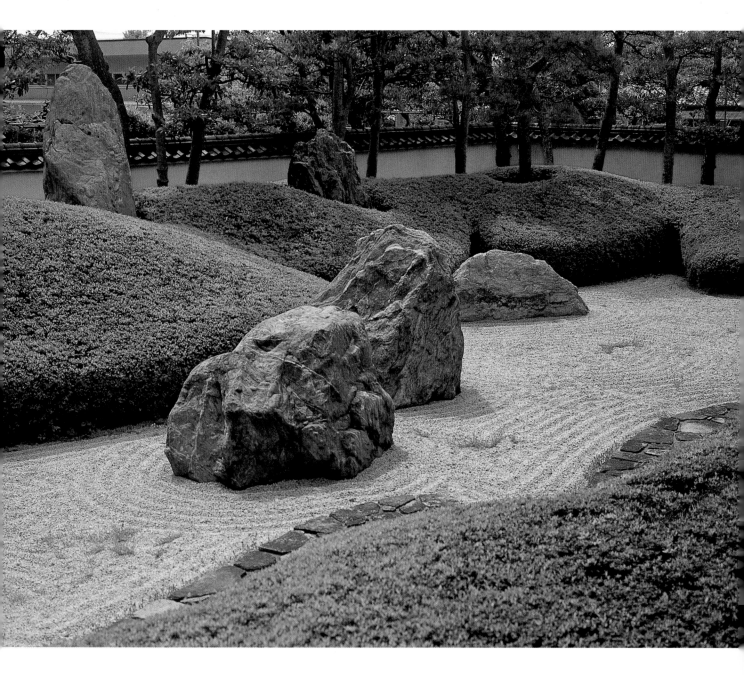

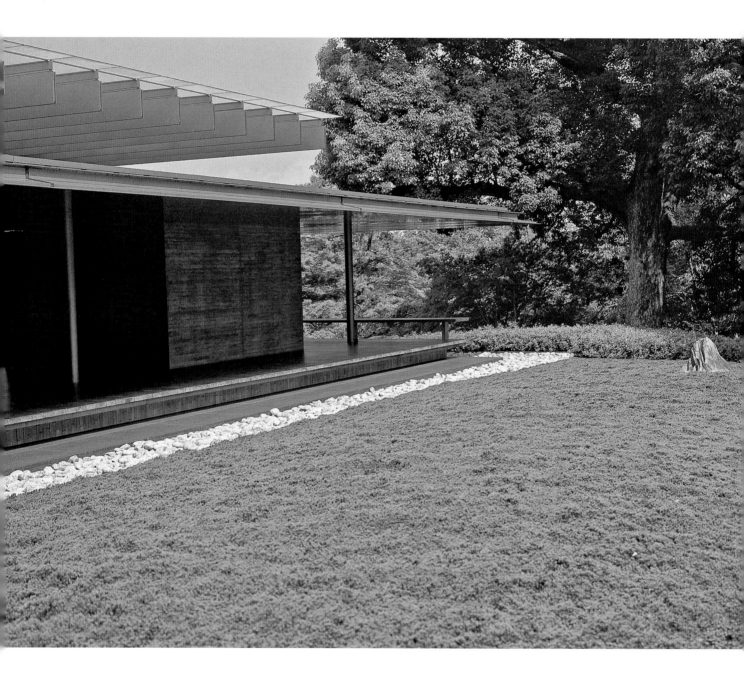

While combinations of cut and natural stones are commonly used these days, some landscape designers are reacting against the current canons of taste, trying to revive purer forms of stonework that resemble the great gardens of the past. Aside from gardens designed or renovated for temples, the instances of new gardens that both deviate and hold faith with the origins of stone garden design are those that are privately commissioned by clients as home gardens, and those used to enhance the ambience of traditional hot springs in the countryside, where rock compositions surround steaming pools.

Stone gardens have found a new acceptance and following in contemporary urban Japan as the need to create illusions of space, optical enlargements within highly confined parameters, has become the norm, particularly in space-pinched urban settings like Tokyo. Stone gardens are well suited to the bleak urban settings of today's cities, the hard textures and surfaces of buildings, the towering skyscrapers that lend themselves as the new "borrowed scenery" in place of mountains and jagged cliffs.

The planners of today's degraded cities, stretched to the limit by overcrowding, lack of greenery and islands of trapped heat, could learn a great deal from the cultivation of small spaces. These tight, almost modular gardens, though dry, are fragrant to the senses, offering us the gift of spiritual refreshment and regeneration.

In this context, the art of the stone garden is clearly far from extinct. A Buddhist temple, private residence, even a hotel, will, if it has the financial means and requisite vision, still commission the layout of a stone garden and, if it is a design executed by one of the modern masters, the result will be an enduring work of spatial sculpture.

Today's garden designers, however, are a different breed from those of yesteryear. Holding university degrees, their training reflects international as well as domestic influences. Individual self-expression overrides a more traditional collaboration with nature as designers move closer to the domain of sculpture. These products of the imagination have been aptly dubbed "mindscapes" rather than landscapes.

Today's builders of stone gardens are mostly professionals with offices, design teams, computer graphic software and hi-tech construction equipment. Unlike the priests, painters and

LEFT The clean, austere lines and expanse of moss used in Shun Miyagi's 2001 dry landscape garden appeal to both traditional and modern tastes. Located within the grounds of the Byodo-in Temple in Uji, the garden stands adjacent to a museum housing the temple's priceless treasures.

RIGHT Thin lines depict the outline of clouds at Mirei Shigemori's Kozen-ji Temple garden in Kiso Fukushima.

aristocrat enthusiasts of the past, they may not always have a personal connection to the site or a deep interest in the evolution of the garden beyond their use of conferring prestige and recognition on the designer once the project is completed. Others contend that innovation of this sort is a sign that the stone garden is a dynamic, ever-evolving form.

THE GARDEN COMMODITY

There are serious concerns about the environments in which older gardens are situated. Dusty, colossally polluted urban cities have grown around many landscapes, testing the original designs with visual distraction, crowding and noise.

Gardens like Ryoan-ji and Ginkaku-ji have become commercial goldmines, playing host to hundreds, even thousands of visitors on peak days, making leisurely, quiet meditation of the gardens almost impossible. Some garden authorities have taken steps to preserve the original intentions of the garden builders by either restricting the number of visitors, requiring them to make a written application to visit or, as in the case of Entsu-ji in Kyoto, prohibiting the use of cameras and videos.

Some prominent gardens have, inevitably, been vulgarized by the commercial ethic, suffering as a result. Vending machines and kiosks dispensing snacks and souvenirs inexplicably occupy sections of garden buildings, even temples; at

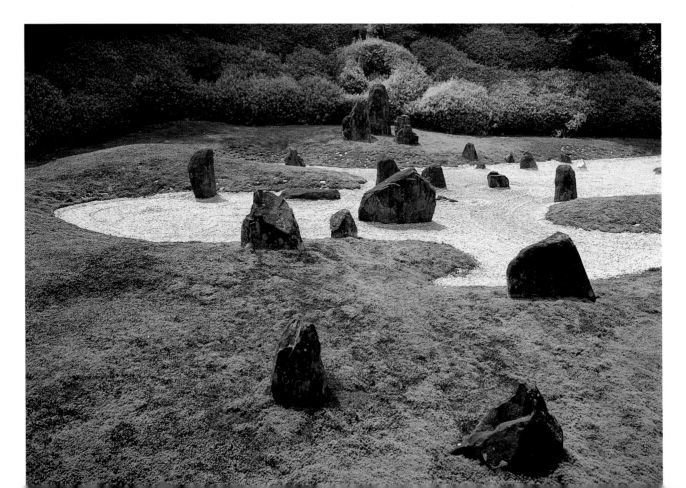

OPPOSITE One of three triad stone arrangements is visible at the rear of Mirei Shigemori 's garden at Komyo-in, a sub-temple of Tofuju-ji.

LEFT Straw sandals left by a monk on a *kutsu-nugi-ishi* or "shoe-removing stone."

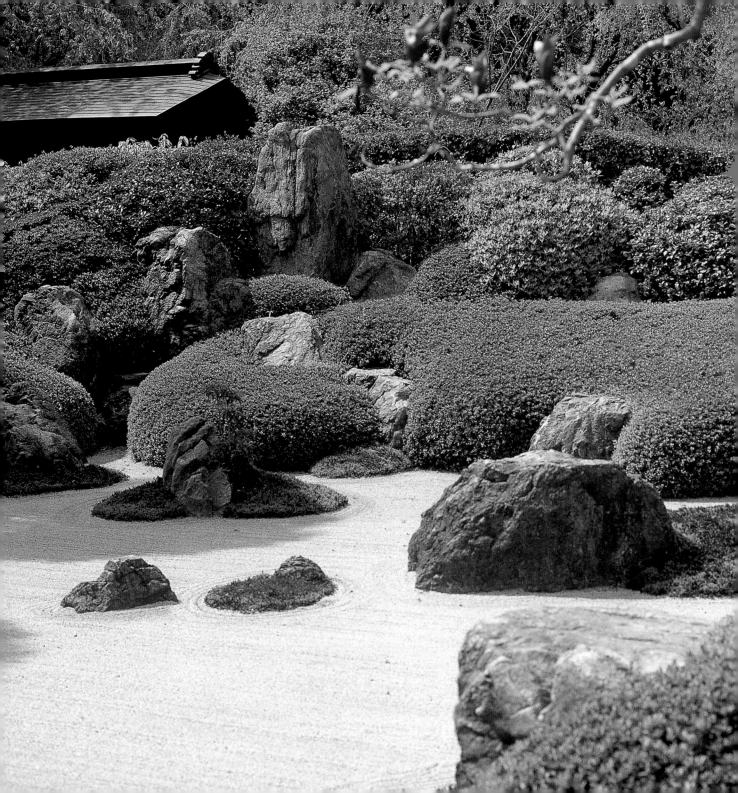

LEFT A Buddhist view of the world contained in a modern stone arrangement at Meigetsu-in, a hermitage in Kamakura.

Kyoto's Taizo-in, ashtrays have been placed under the wisteria arbor for smokers. In an atmosphere more akin to a theme park than a garden, bottled drinks are consumed, cell phones are answered and calls are placed.

In such conditions, the values embodied in Japanese gardens, the unassailable refinement of the designs, may be lost on some of today's visitors, the environments of gardens barbarized by the comportment and scale of the modern visitor, the tour and high school groups that arrive by the bus load. If there are "a limited number of people who can build a genuine Japanese garden based on Japanese traditions and the Japanese mind," as one well-regarded landscape designer asserts, that may be because the majority of Japanese no longer possess this "Japanese mind."

THE POWER OF GARDENS

They're just stones, aren't they?... I'm sure you see a kind of power and mossy beauty radiating out of them, the way you look at them.

Yasunari Kawabata, *Beauty and Sadness*

If one stares at a stone garden for long enough, it may have a mildly hallucinatory, tranquilizing effect. Amplified and frozen as they descend into the earth, lines radiating from rocks in perfect circles suggest ripples from a pebble as it strikes the surface of a pond, or the circles called *enso* drawn by Zen monks in black ink as symbols of enlightenment. Or again, the circles in the sand around key rocks may be likened to the perambulations made by monks around the stupas of Southeast Asian temples. In this light, gardens can be seen as mnemonic devices, stimulating a surge of associations and imagery. Concentrating on the design, a sense of infinity takes hold and the prescribed limits and boundaries of the garden dematerialize.

The most accomplished gardens achieve such levels
of sublimity because we recognize that within them there
is both emptiness and fullness, brevity and length, an extra-
ordinary spatial condition. Because the stone garden is not
generally a place to stroll in, to physically enter, it must be
contemplated in the manner of art, from a fixed position,
a prescribed viewpoint. And, as in the presence of any truly
arresting image, personality is temporarily subsumed when
viewing these spatial works.

One of the functions of gardens is to bring us into
alignment with nature, the universe, our inner selves.
Though rarely stated, this is implicitly understood. So too
is the idea, however vaguely sensed, that gardens can be
healing and regenerative. For those with the requisite sense,

ABOVE A stone grouping in a shopping and office plaza in Makuhari,
Chiba Prefecture, challenges the definition of the dry landscape garden.

OPPOSITE Dynamically arranged stones at one of the five gardens
attached to Jonangu Shrine in Kyoto.

there are currents, energy flows, dialogues to be discerned in
the Japanese garden. Gardens possess the power to still the
nerves, to set in motion a line of inquiry, a series of questions,
a train of thought, which are poetic and thaumaturgic.
According to Zen, human energy and power is at its optimum
when we attain a condition of composed calm and poise in
which we can face life with equanimity and sincerity.

These gardens lend themselves to intellectual calm and
repose, an aspect of Japanese yearning increasingly denied in

the flurry and pressure of modern life. To step into one of the quieter, less trammeled gardens is to pass through a door from ordinary life into an abrupt stillness, a place where we can feel the tense knots loosening.

There is a cognoscente of garden admirers who will tell of extraordinary dry landscape creations tucked away in the folds of hills of Kyoto, or concealed between residential lanes that receive little more than a respectful trickle of visitors.

Shoden-ji, a small temple sitting on a graduated hillside at the end of a flight of stone steps rising through a forest of cryptomeria trees, is one such place. To reach its garden, you pass over a brook whose water is cool and unstanched even on a humid summer afternoon. As the custom requires, you remove your shoes at the entrance to the temple and then step onto the time-worn zelkova deck, facing a garden framed by white, tile-capped walls. A corridor of trees draws the eye to the distant, borrowed outline of Mount Hiei, to the northeast of Kyoto city. Azalea bushes divided into groups of 7-5-3, a pattern reflecting the Taoist notion of the harmony of uneven numbers, sit on a flat plane of raked gravel.

A true contemplation garden, it is a place to breathe deeply of the slightly elevated woodland air, to appreciate the garden in the manner it was intended – in the company of the gods. In Joseph Cali's *The New Zen Garden: Designing Quiet Spaces*, landscape designer Sadao Yasumoro's preliminary approach to building a new garden, to communicating with its *genius loci*, is recorded: "While listening to the *kami* living at the site, and bearing in mind the feelings of the owner, I begin to work." In settings like this, we discover that tradition, far from being obsolete, is perfectly compatible with the age in which we live. This is the lesson the Japanese stone garden teaches us.

JAPAN'S EXQUISITE
STONE GARDENS

Visiting Japan's Gardens

Most people who take an interest in Japanese gardens will likely first visit the famous temple gardens of Kyoto. This book is the result of successive visits over the years around the main islands of Honshu, Shikoku and Kyushu, even the faraway subtropical islands of Okinawa. A particular interest in stone gardens, a quintessentially Japanese form, developed on these trips and many gardens were revisited in order to yield fresh perspectives on their unique designs.

Gardens are the fruit of sophisticated civilizations. In the case of Japan, where castles and temples were built, arts and crafts established, gardens often followed in their wake. Because of this, most of the dry landscapes that appear in this book are located in cities and towns with bona fide cultural credentials. They are, in other words, very much on the map and relatively easy to access by public transport. Some may require a short walk from the nearest bus stop or train station. In the case of Kyoto, a city

accustomed to large numbers of visitors, the names of some temples are even included on bus schedules. Tourist information offices exist in even relatively small towns, usually located in or near main train stations. They can usually provide good maps and background information, often in English, to where gardens can be found.

Karesansui are all-season gardens, but the borrowed views that often form a part of the design concept are best appreciated between April and November. Some garden lovers, however, swear by the winter months, when landscape designs (and the number of visitors) are reduced to their bare bones.

1 RYOAN-JI

2 KENNIN-JI

3 RYOGEN-IN

4 FUNDA-IN

5 TOFUKU-JI

6 MATSUO TAISHA JINGA

7 SHODEN-JI

8 KISHIWADA CASTLE

9 RAIKYU-JI

10 ADACHI MUSEUM

11 SENSHUKAKU PAVILION

12 JOEI-JI

13 CHIRAN GARDENS

14 CANADIAN EMBASSY

15 MIYARA DUNCHI

Ryoan-ji

During the Heian period, the grounds of Ryoan-ji (Dragon Peace Temple) belonged to the powerful Fujiwara family, though only Kyoyochi pond survives from that time. Katsumoto Hosokawa founded the temple in 1450 but it had to be rebuilt in 1488 after being destroyed in the Onin War (1467–77). Yet another fire ravaged the temple in 1790 but the garden, dating from around 1499, remained undamaged. The designer of the garden remains a mystery though Soami (1472–1523) has been credited. Some scholars believe the more likely creators of the garden were *kawaramono*, outcast riverbank dwellers who became Japan's first full-time gardeners. Outside of serious garden circles, Ryoan-ji, located on the north-western edges of Kyoto, was virtually unknown until the 1930s. A superb example of the dry landscape garden in which raked gravel, sand and stone are substitutes for water and landscape features, the garden's mastery of space and form relies on the artful placement of fifteen rocks in groupings of 5-2, 3-2 and 3. These are arranged into 7-5-3 sets. Viewed from the verandah, one rock always remains hidden from sight. In keeping with the abstract nature of the garden, designed as a tool for meditation, the viewer is left to complete the landscape and discover its meaning. There is little plant life in the garden, save some patches of moss at the base of the rocks. Clean, mathematical lines are softened by the rusticity of the mottled, clay-colored wall enclosing the garden. Many Zen priests have asserted that, through intense meditation, it is possible to be transported into the garden itself and catch a glimpse of infinity in its landscapes, a claim that has only added to its profound mystery.

PAGES 86–7 View from the tea house at the Funda-in Temple garden in Kyoto.

RIGHT Ryoan-ji's unsurpassed mastery of form and space have made it one of the best-known gardens in the world.

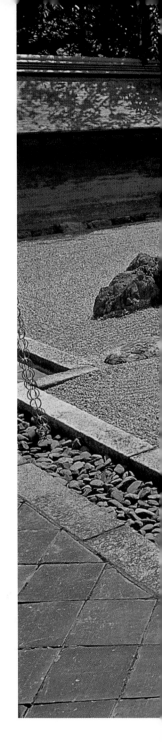

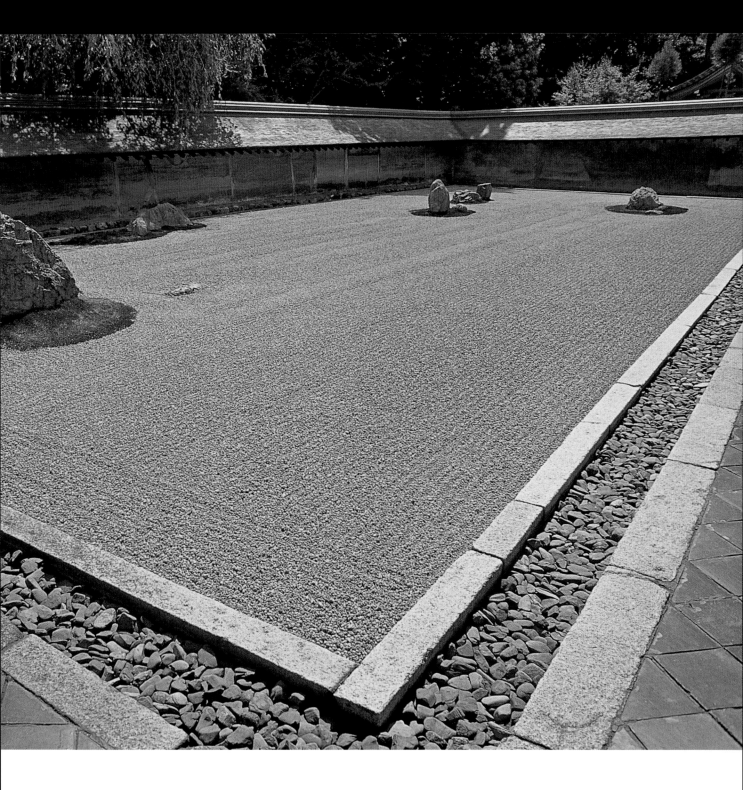

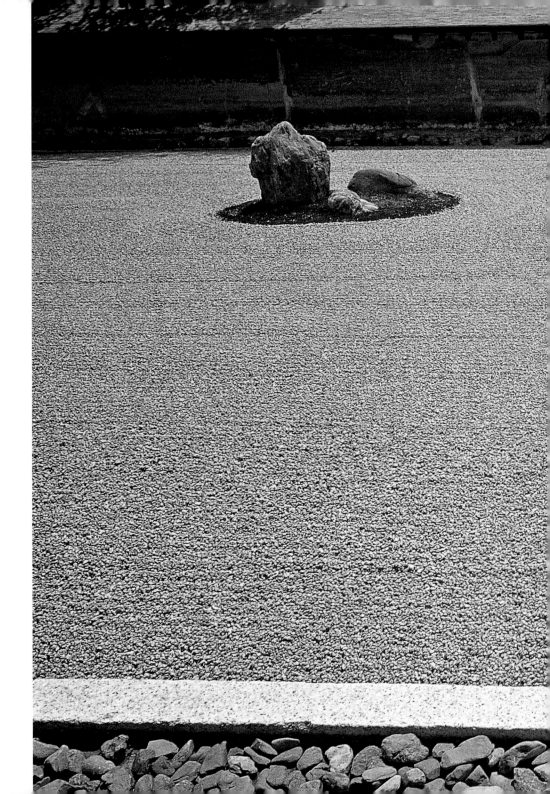

RIGHT Austere and unembellished, with no visible plantings except moss, the garden is attached to a Rinzai Zen Buddhist temple.

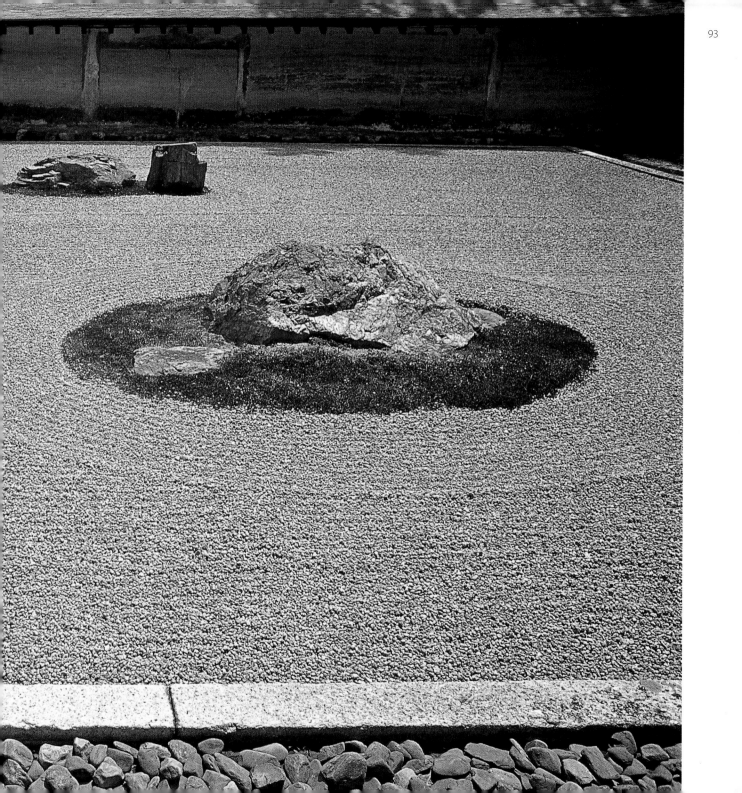

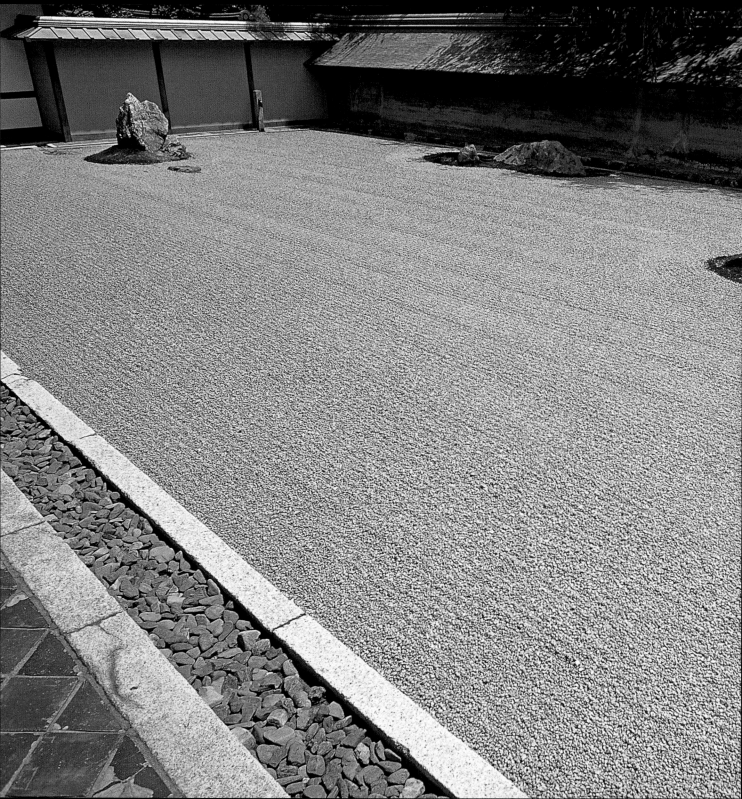

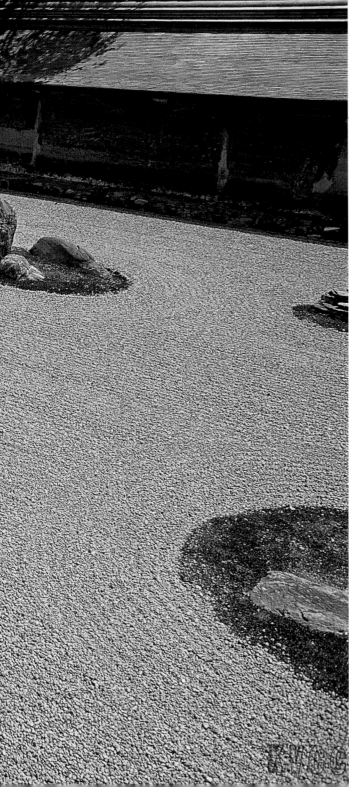

LEFT Built on a level plane without any artificial hills or mounds, Ryoan-ji is characterized as a *hira-niwa* or "flat garden."

ABOVE Surrounding the *kyoyo-chi* (mirror pond), built within the grounds of Ryoan-ji in the late twelfth century, are cherry, pine, iris and camellias brought from Korea.

Nanzen-ji

The two main buildings at Nanzen-ji (Southern Temple of Enlighten-
ment), a complex of halls, rooms and abbot's quarters nestling in the
beautiful eastern hills of Kyoto, were rebuilt in 1611. The garden was
created at a later date. Kobori Enshu is thought to have been the
designer. The current garden was painstakingly restored by Kinsaku
Nakane in the 1970s. A classic *karesansui*, stones decrease in size west
of the large rock set in the southeast corner, and are then subsumed by
a diverse arrangement of shrubbery. A bed of carefully tended moss, pine,
azalea and maple harmonizes with the large rectangle of white gravel.
Countless meanings and forms have been attached to the composition,
the best known and most fanciful being the *Tora-no-ko-watashi* or
"Young Tigers Crossing Water," a name suggestive, it has been said, of the
stone arrangement's evocation of a family of tigers on the move. Such
poetic interpretations are appealing but ultimately rather futile. Visitors
should assign their own significance to what they see. Although an
impressive garden, its stone arrangements lack the subtlety and refine-
ment found in earlier Muromachi and Momoyama period designs. The
great merit of the garden is its ability to fuse and harmonize the enclosed
space with walls, temple structures, roofs, distant forest and hills. The
largest rock in the garden, whether by a happy coincidence or more likely
design, replicates the outline of Mount Yokakuryo in the background. The
success of this blending, the creation of a highly unified, layered massing
of forms and requisitioning of borrowed scenery, has made the view
from the verandah a composition recognizable to almost every Japanese.
Exploring the side and rear gardens via a number of raised passageways
reveals a series of interesting sub-gardens.

RIGHT Bands of
shadow emphasise
a sense of geometry
at a side garden in
Nanzen-ji.

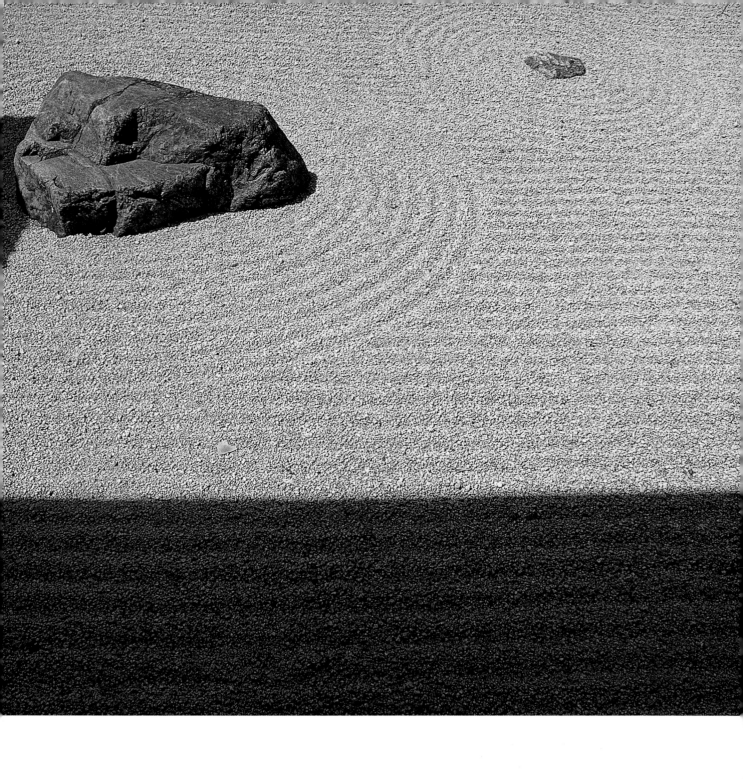

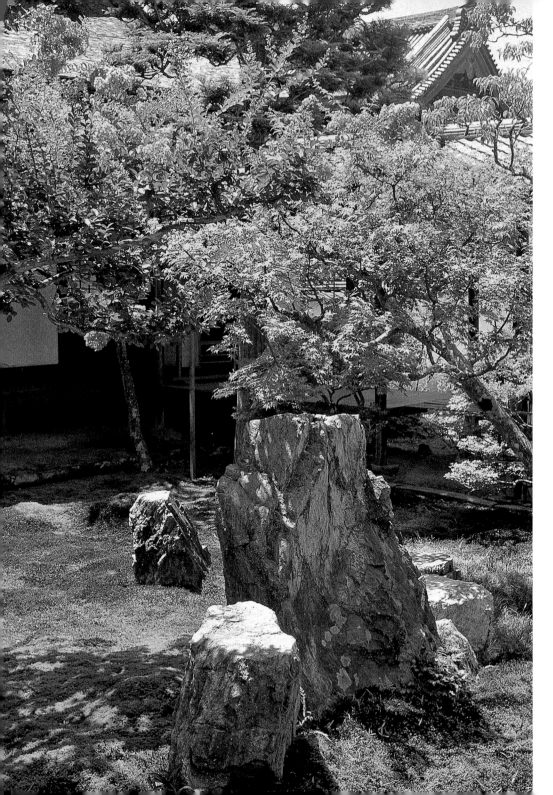

LEFT Crepe myrtle in full bloom above the rocks and moss of a side garden at Nanzen-ji.

RIGHT South of the *hojo* or abbot's quarters, the principal dry landscape garden at Nanzen-ji occupies a fine location set against forested hills. Thought to have been designed by Kobori Enshu around 1600, it was restored by Kinsaku Nakane in the 1970s.

RIGHT AND FAR RIGHT
Two views of a side garden at Nanzen-ji seen from an open-sided corridor.

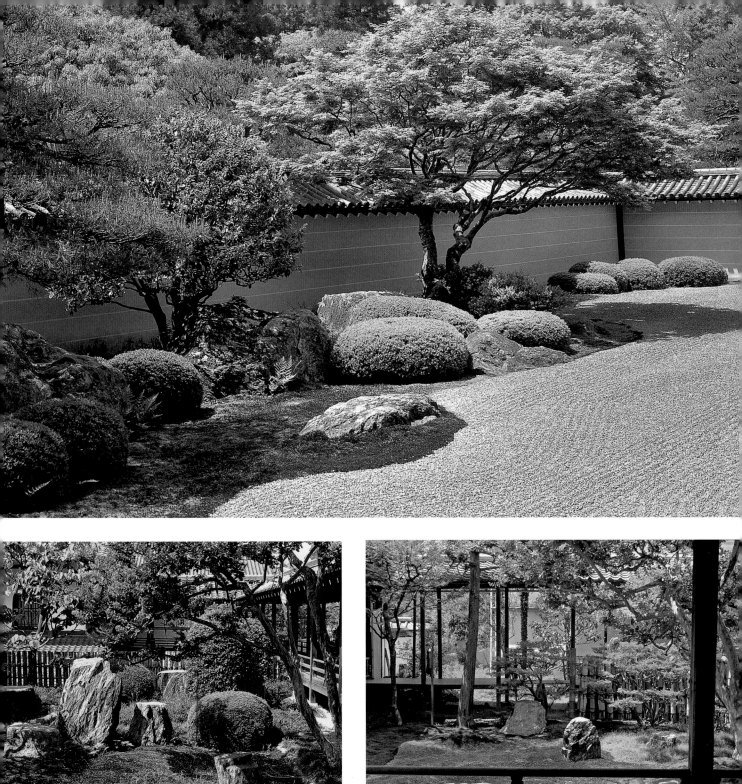

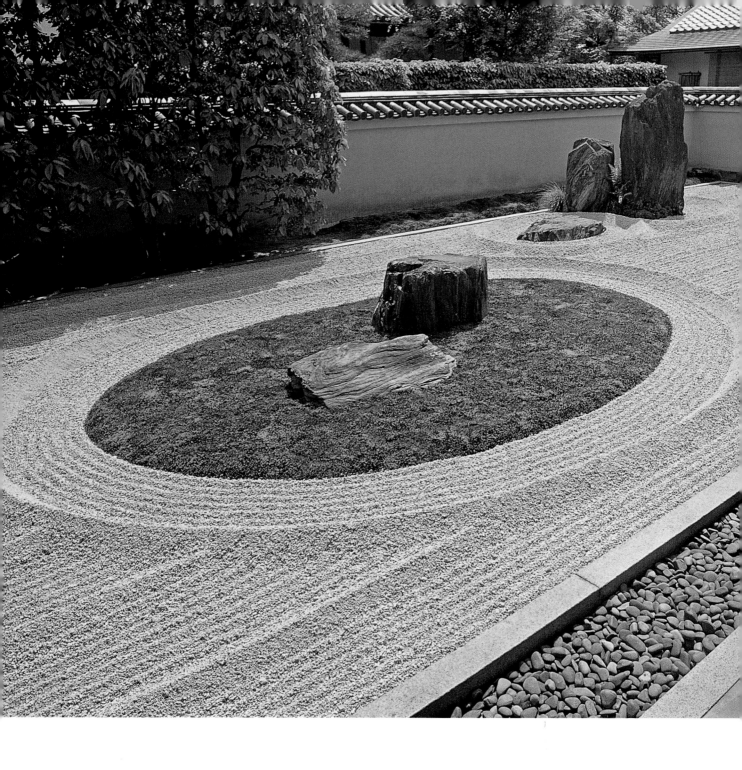

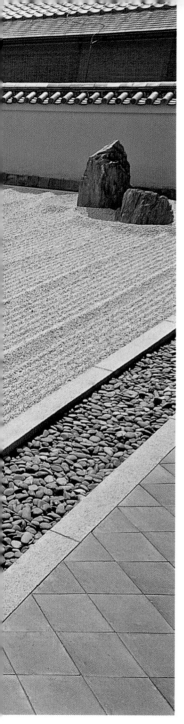

Ryogen-in

A sub-temple of the great Daitoku-ji complex, the gardens at Ryogen-in date from the Muromachi period (1333–1568). The compact grounds contain a fascinating ensemble of five gardens. The Ryugin-tei (Dragon Singing Garden), a Shumisen-style stone design, is one of the oldest *karesansui* in Japan. Thirty rocks, including the central *sanzonseki* grouping of three stones, a standing central rock and two lower "sentries," sit in a bed of spongy spruce moss representing a vast ocean. The tallest rock of the three, tilted eastwards, represents Mount Shumisen. The temple literature cites Soami as the creator but this is a disputed claim, with some garden specialists attributing it to Soboku Tokei, who founded the temple in 1502. A third group of scholars claims that the garden was completed after Tokei's death in 1517.

A slim *tsuboniwa* (courtyard garden), called the Totekiko, lies between the main temple and the kitchen. Constructed in 1958 and consisting solely of small rocks and sand, its understated refinement makes it one of the most interesting gardens at Ryogen-in.

The clean, almost contemporary angularity of another garden, the Isshiden, is attributable to renovation work that took place in the 1980s. The name is derived from the temple's founder, Tokei, who, having solved a difficult Zen riddle, was given the name Ryozan-isshi-no-ken. The simplicity of the design makes it easy to pick out its symbolism: islands and rocks representing the crane and tortoise themes and China's mythical Mount Horai, the dwelling place of immortal sages, artfully positioned in an expanse of ocean symbolized by raked white sand.

LEFT Restored in the modern period, the Isshidan's crane and turtle islands and its mythological Mount Horai stone arrangement are traditional motifs.

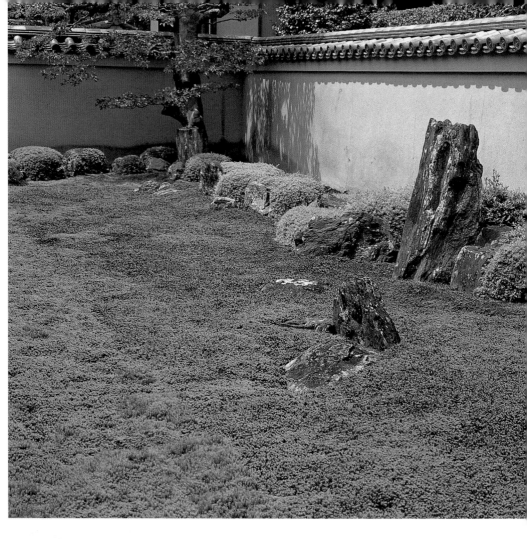

ABOVE The simple refinement of a narrow *tsuboniwa* (courtyard garden). Designed in 1958, it is a later addition to the gardens at Ryogen-in.

RIGHT An iron lantern along the east side of the temple contrasts with afternoon shadow and *sudare* (reed shutters).

ABOVE One of the oldest dry landscape gardens in Japan, the northern-facing Ryugin-tei (Dragon Singing Garden) was built in the early 1500s. The moss-covered garden is dominated by a sharply angled rock representing the mythological Mount Shumisen.

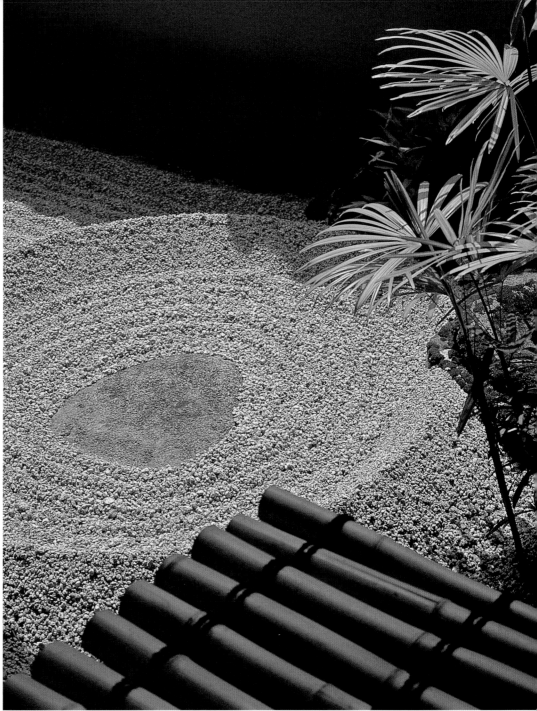

RIGHT Said to be the smallest rock garden in Japan, the Totekiko consists of a stone representing a single drop of water dropped into a limitless sea, its ripples connecting with the infinite and the boundless.

Funda-in

The setting of Funda-in, with its wall of camellias and bamboo, spherical-shaped topiary, moss and gravel speak eloquently of a different age, the period of its creator, the great gardener-painter Sesshu (1420–1506). The garden is sometimes referred to as the Sesshu-in.

A small sub-temple of Tofuku-ji, this exquisite but largely overlooked garden originally featured two crane and turtle stone compositions set in a bed of moss. For some reason, the crane setting was dismantled during the early nineteenth century. Fire and neglect also played a part in destroying the original composition of the stone garden.

The southern section of the garden contrasts raked sand with an expanse of moss bordered with trees and hedges. The two rock groupings, rising from a foaming green sea of moss, are islands only in the symbolic sense. Crane and turtles, along with the pine trees used in the garden, are traditional symbols of longevity. The eastern garden has more rocks embedded in moss, a chain of stones representing the mystical Isles of the Immortals in the East Sea.

To the rear of the abbot's hall is a tiny tea garden and tea house. The view from inside the tea house through the circular moon window forms a beautiful, painterly composition. The garden was restored by Mirei Shigemori in 1939. He added a small crane and turtle garden to the east side of the garden, beside the abbot's hall. Although the authenticity of the current garden may have been lost to some degree, the spirit of Sesshu's original composition is skillfully embedded in the more contemporary restoration.

RIGHT The garden's main turtle island is built on two levels of stone. Pressed flowers set in the hand-made *shoji* paper of the shutters are visible in the foreground.

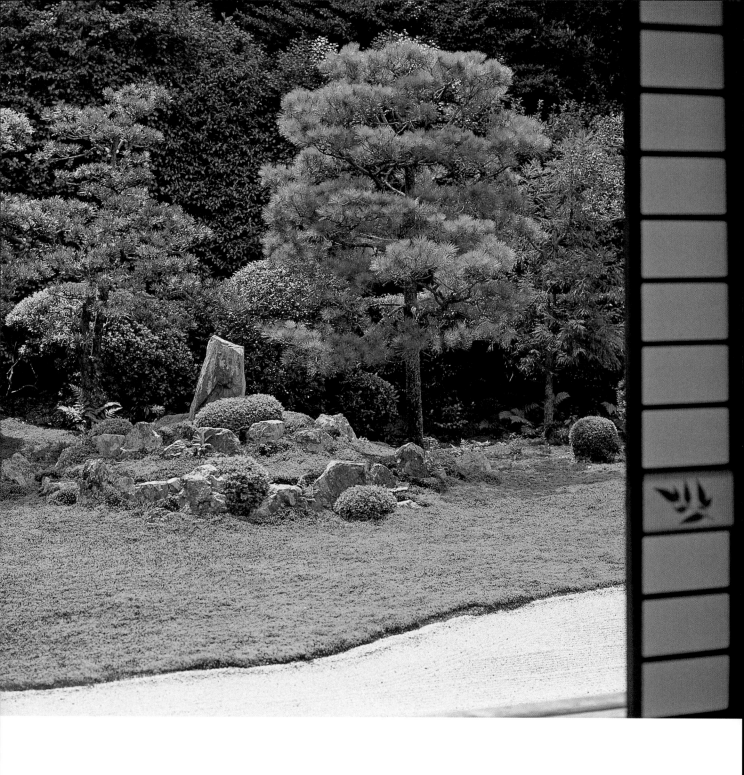

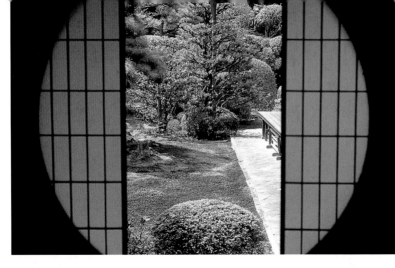

LEFT The side garden view from inside the tea house reveals moss and small stone settings representing more turtle, crane and Mount Horai groupings.

BELOW Built about 1465, the garden's main turtle island is erected on two levels of stone. Turtles and cranes are symbols of longevity.

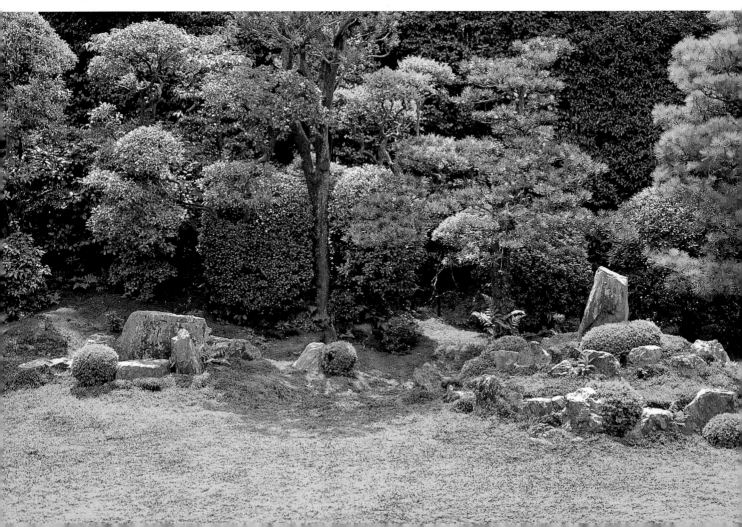

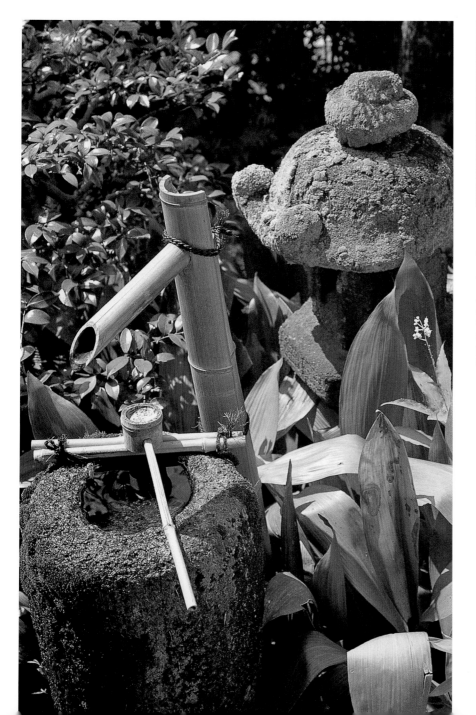

LEFT A classic concentration of garden ornamentation that includes a water basin, bamboo water pipe and stone lantern.

ABOVE A temple roof finial. Its appropriation like this is a good example of the use of suitable recycled objects with the purpose of adding character, age and cultural depth to gardens.

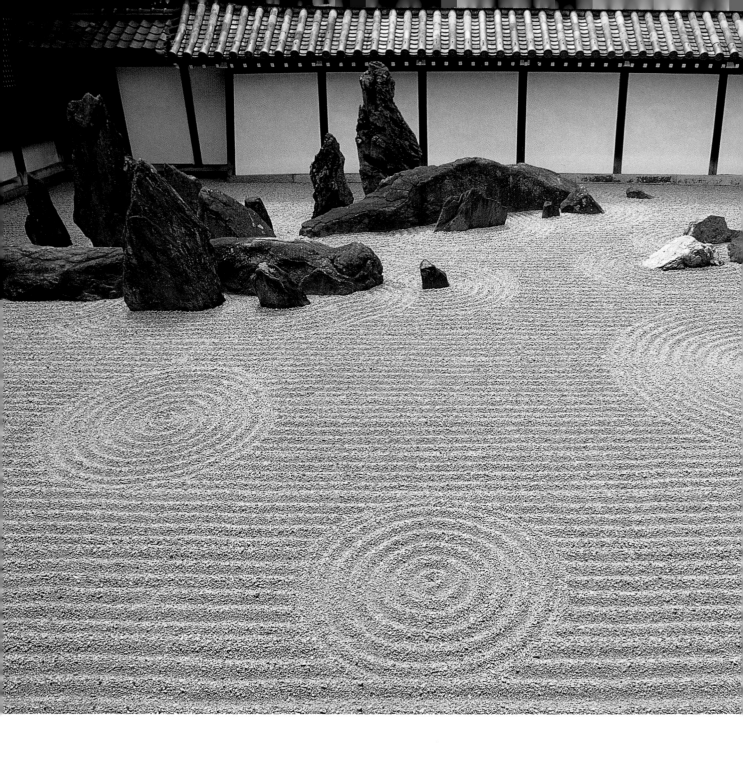

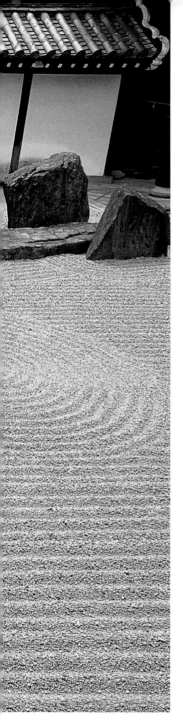

Tofuku-ji

Tofuku-ji, the head temple of the Rinzai School of Zen, was founded in the Kamakura period (1185–1333), at a time when Zen Buddhism was beginning to flourish. Mirei Shigemori was asked to create the Abbot's Hall garden in 1938. As the temple was in debt at the time, he offered to do the work free of charge on condition that he had a completely free hand in its design.

The work that Shigemori created was called Hasso no Niwa (Garden of Eight Phases), a reference to the eight stages in the life of the Buddha. The south side of the Abbot's Hall garden is designed in the Zen tradition, with a seemingly infinite expanse of gravel representing the sea. The stone setting in the eastern corner of the garden symbolizes the Chinese mythological Islands of the Immortals, while the moss-covered mounds to the west represent the five main temples of Rinzai Zen Buddhism.

Paving stones were used in the northern garden to create a startling checkerboard pattern of stone and moss. Based on a traditional design called *ichimatsu*, square stones formerly used as part of an entrance path are juxtaposed with cedar moss to create a vision of flat rice fields. The effect on the viewer of this moss and stone matrix is very contemporary, drawing comparisons with the work of the European abstract painter Piet Mondrian. In creating the eastern Garden of the Big Dipper, the first garden in Japan representing the constellations, Shigemori reused seven cylindrical foundation stones taken from the temple's latrine building. The northern and eastern gardens are good examples of *mitate-mono*, the use of old objects as garden elements.

LEFT Landscape elements are used to great effect in the southern garden, in front of the Abbot's Hall, the largest section of the Hasso no Niwa (Garden of Eight Phases).

LEFT The verdant and watered hillside garden at Kaisan-do (Founder's Hall), a sub-temple of Tofuku-ji, sits opposite a rectan-gular plane of sand.

RIGHT Moss-covered hills in the corner of the Abbot's Hall southern garden represent Kyoto's five principal Rinzai Zen temples.

BELOW RIGHT Stone elements of the pond and hillside Kaisan-do garden, built in the early 1600s.

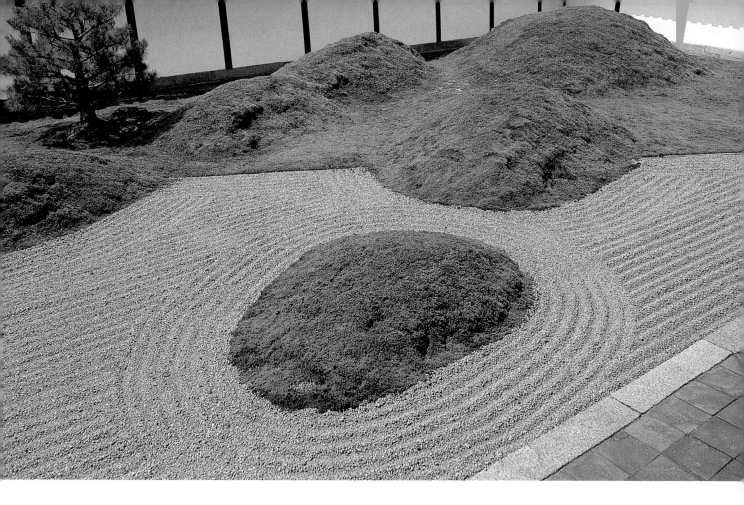

The older garden at Fumon-in, a nearby sub-temple of the Tofuku-ji complex, has a meticulously maintained sand plain, raked into a checkerboard pattern that may have influenced Shigemori's thoughts when he came to designing parts of the Abbot's Hall garden. A mass of rocks, moss and shrubs, forming the shape of a crane and tortoise, are banked up in one corner of the plain. The opposite side of a dividing path consists of stone bridges over a pond, carefully clipped topiary, rocks and stone basins in a composition that provides a verdant contrast to the dry landscape western portion of the garden.

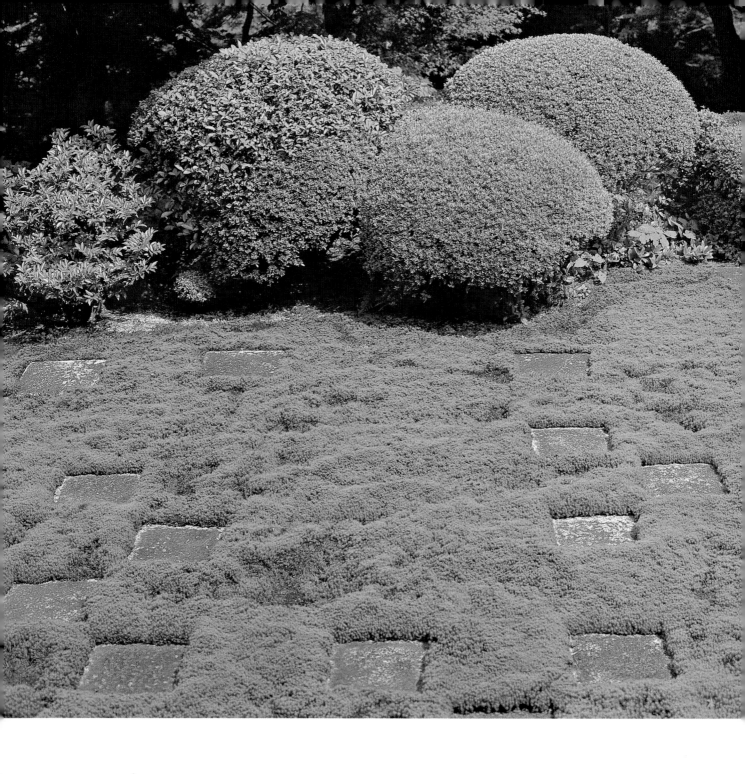

LEFT The grid of flat stones and moss in the northern section of the Abbot's Hall garden is based on a traditional design known as *ichimatsu*. The paving stones were taken from an old entrance path.

BELOW An energetic tension is created between the densely compressed shrubs, rocks and moss that comprise the eastern portion of the Kaisan-do garden and its plain sand matrix.

RIGHT An immaculate checker-board pattern of sand dominates one half of the Kaisan-do garden.

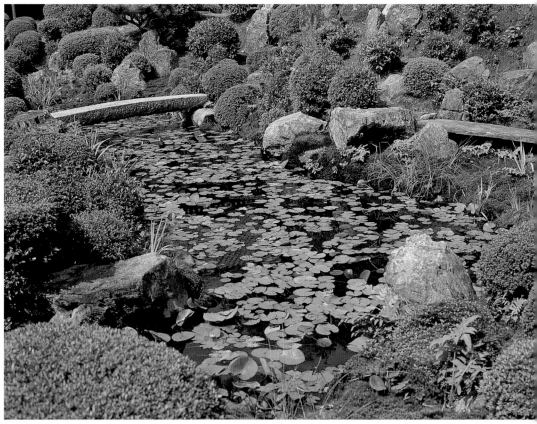

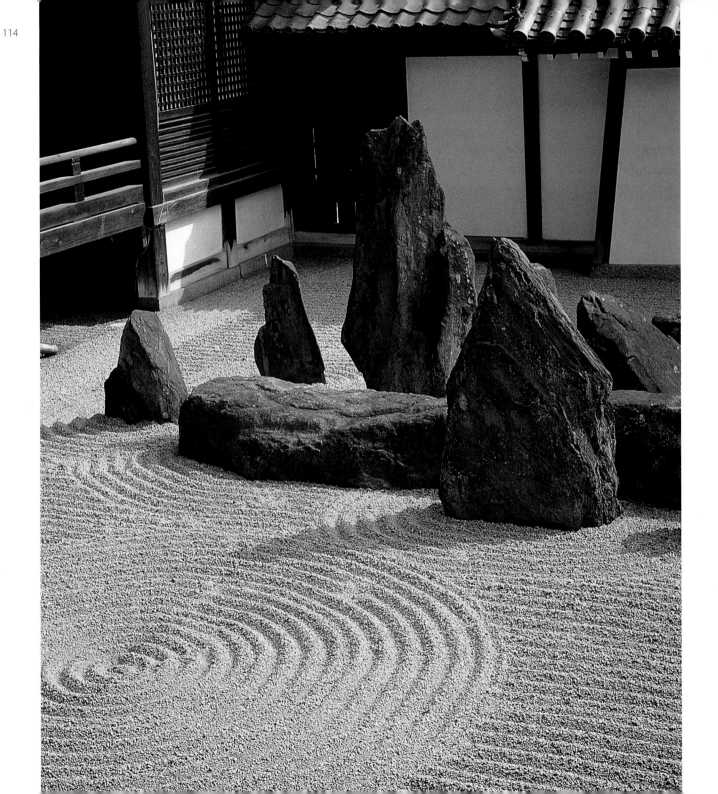

LEFT Like many stone gardens, Tofuku-ji depends for its design effect on a strict enclosure of space.

BELOW This arrangement, representing the Big Dipper constellation, is composed of foundation stones taken from a former outhouse.

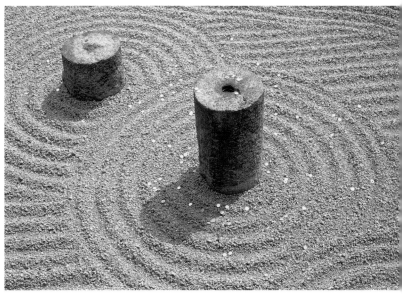

LEFT One of four rock settings in the southern section of the main Abbot's Hall garden, depicting the Islands of the Immortals.

ABOVE Tight concentrations of tile, stone and gravel are common in *karesansui*.

Matsuo Taisha Shrine

The gardens at Matsuo Taisha Shrine, Kyoto, are designer Mirei Shigemori's last works and, according to some, his final masterpieces. He designed three gardens here, two of which can be considered stone gardens.

The first, known as the Kyokusui no Niwa (Garden of the Undulating Stream), is adjacent to a concrete treasure house and ceremonial building constructed in 1973. A river flows from Mount Matsuo into the garden, forming a shallow, winding stream. Entering the garden from the south-west and exiting in the north, the stream's banks are lined with flat, blue stones, while the bottom of the channel is covered in gravel. In the background, an assortment of large and smaller rocks stand in the midst of an undulating mound of azaleas. Clipped into the shape of a turtle, they also mirror the outline of Mount Matsuo to the rear of the shrine. The east section of the garden is paved and can be walked on. In declining health at the time of the garden's construction, it took Shigemori a full year to complete. The final part of the work was executed by his eldest son, Kanto, after Shigemori passed away, on 12 March 1975.

Placed on a steep slope beside the treasure house, the Joko no Niwa (Garden of Ancient Times), is a dynamic stone arrangement on a steep slope. In positioning a garden within the grounds of a shrine, Shigemori brought the Japanese garden full circle, creating an *iwakura*, a place for the Shinto gods to congregate. Shigemori believed that the sacred *iwakura* rocks, worshipped as deities in ancient times, were the origin of the Japanese garden. All of the rocks were transported from Shikoku Island and

RIGHT The Garden of the Undulating Stream takes its name from an ancient Japanese ceremony called Doll Floating, in which dolls were sent down rivers on miniature boats, carrying off bad luck with them.

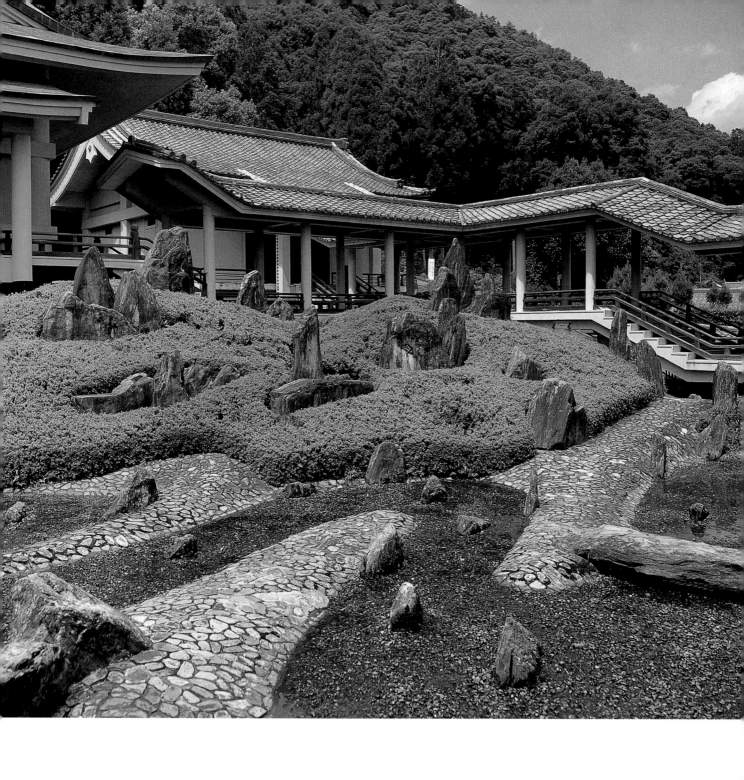

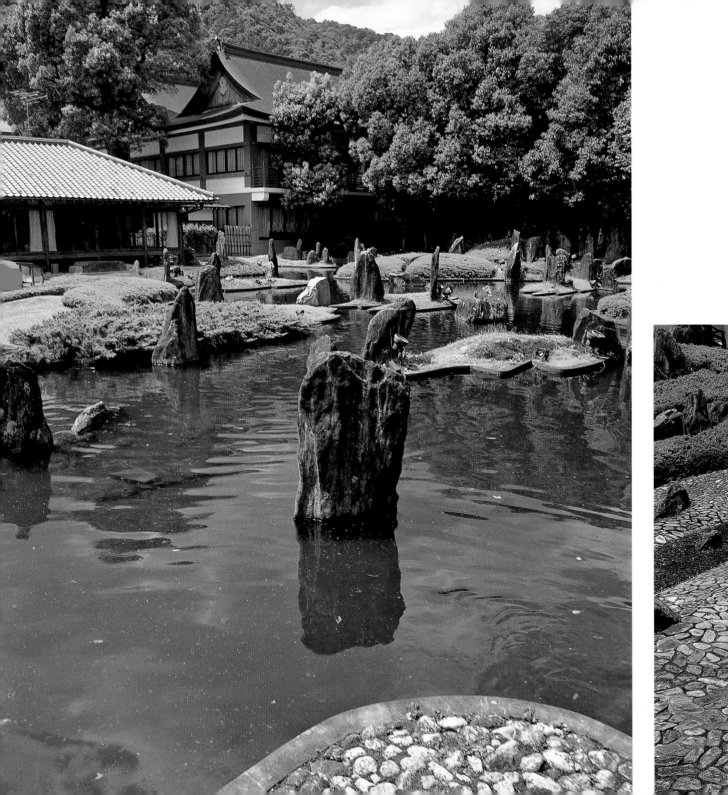

are the variety known as *ao-ishi* (blue chlorite schist). The garden creates an ascending drama, with smaller stones supplanted by larger ones going up the hill until, at the top, the rocks weigh between five and eight tons. Close to his own death, Shigemori reached out to the divine in the creation of this garden, stating that "To set stones for an *iwakura*, the garden designer must acquire an identical mentality to the gods.... What this is about is how close a garden maker can get to the gods, and how pure his mind can become."

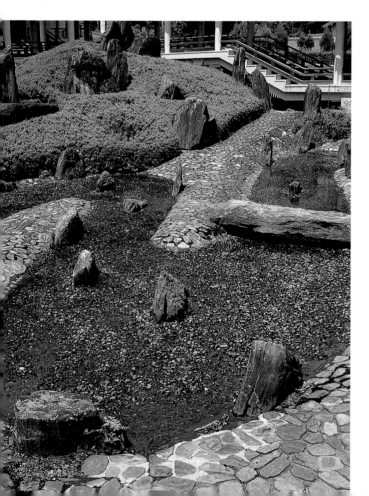

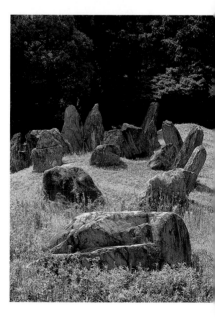

OPPOSITE The Horai Garden was designed by Mirei Shigemori but completed by his eldest son, Kanto.

LEFT *Karesansui* are rarely found at shrines. Adding to the uniqueness of this contemporary garden is the use of water, tile and cement.

ABOVE The trademark wave designs Shigemori enjoyed using for paving stones.

RIGHT In the Garden of Ancient Times, Shigemori returned to the origins of the Japanese garden by creating an *iwakura*, a place for the gods to visit.

Shoden-ji

Like many stone gardens, Shoden-ji, an early Edo period *karesansui*, depends on a strong sense of enclosure for its effects. At the same time, its highly naturalistic borrowed scenery liberates the viewer from the immediate boundaries of the garden. From the white gravel beneath the verandah, across a dense forest containing the path that leads to the temple, to the distant outline of Mount Hiei, there are no buildings, high-tension wires or other visible intrusions.

Two sides of the garden are bordered by a white clay wall capped with dark tiles. A gate in the far corner of the wall marks the beginning of a line of dense trees that act as the garden's third enclosure. Instead of using stones as many *karesansui* do to create the auspicious odd number 7-5-3 rendering, it has tightly clipped azalea bushes arranged in that pattern along a south to north trajectory. Even numbered groupings were usually avoided in early Edo period gardens, where the "harmony of odd numbers" recommended in the Chinese *I-Ching* was preferred.

A perfectly composed garden, nestled into the wooded slopes of a benched hillside in a quiet northern area on the edge of Kyoto, Shoden-ji's understated charm lies in its natural setting and rusticity.

RIGHT The silhouette of distant Mount Hiei floats majestically above the tree line, forming a perfect borrowed view.

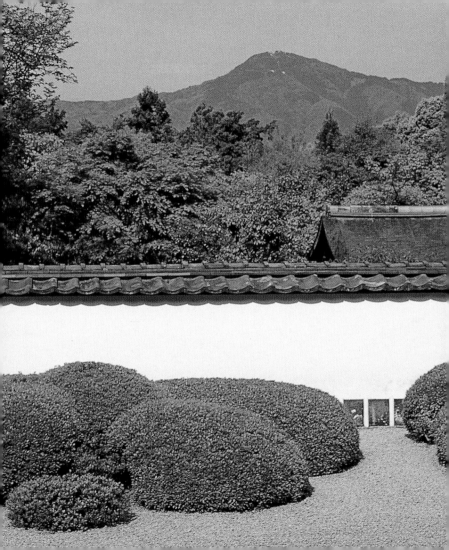

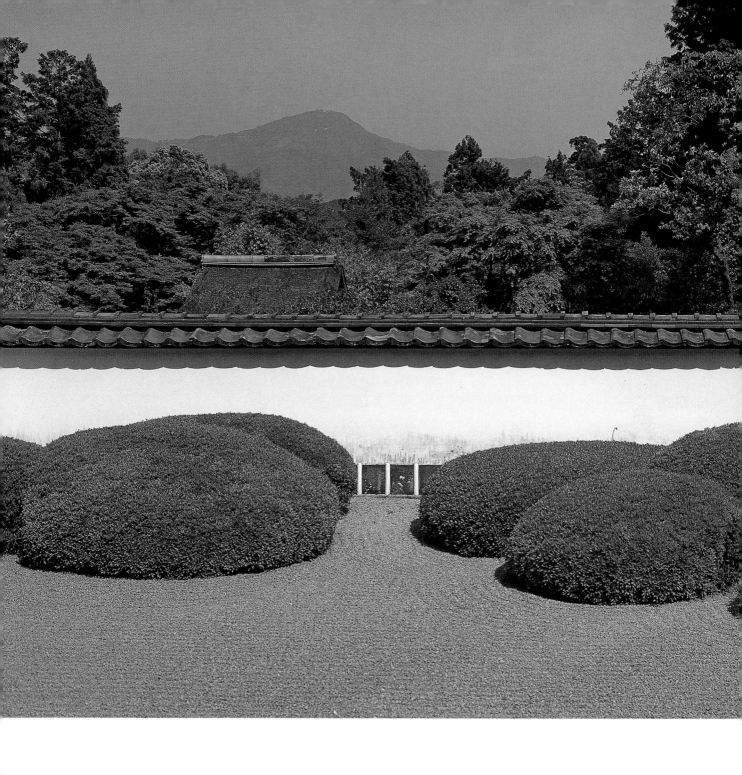

LEFT Trimmed hedges are placed against a tiled white-clay wall to maximize the contrast between the trees beyond the garden and the gravel within it.

RIGHT A basin of real water contrasts with the abstraction of a gravel sea.

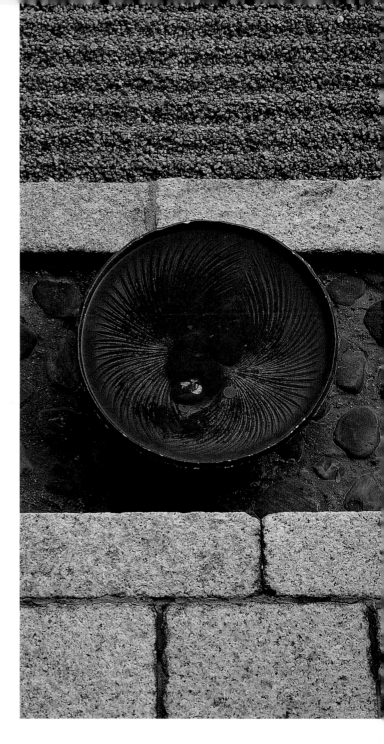

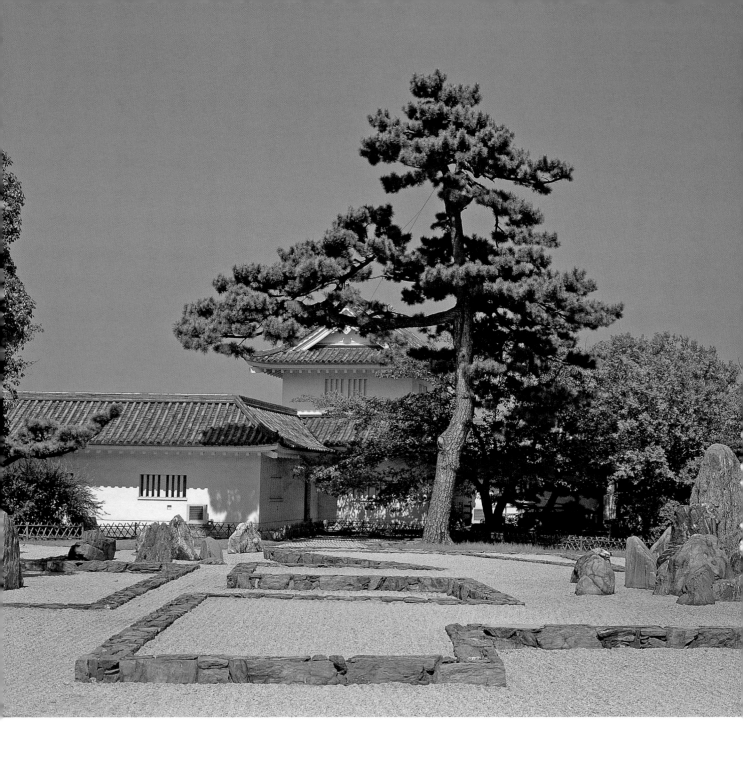

Kishiwada Castle

One of the most remarkable features of Kishiwada Castle and its grounds in Osaka, is a highly original garden, designed in 1953 by Mirei Shigemori. Inspired by the military aspect of the castle, Shigemori's stone settings are also references to the eightfold battle camp formation used by Chinese general Zhuge Liang in an ancient mythological account. The stone setting at the center of the design, aptly called Central Camp, is the garden's main stage. Eight sub-camps, named Heaven, Earth, Wind, Cloud, Dragon, Tiger, Phoenix and Snake, surround the main encampment, which sits on the highest ground at the center of the composition. Shigemori's favorite stone was *ao ishi*, a bluish chlorite schist. Many of these highly assertive stones can be seen here in a design that combines durable materials with abstract ideas.

Unlike many stone arrangements, the garden can be appreciated from several viewpoints. As one circles the edges of the garden, scenes change dramatically. The superb views from the upper floor of the castle help to make sense of the strategic pattern of the garden, revealing a layout that resembles the original castle's fortifications and moats.

Angled dispositions and the use of raised, linear walls rather than simply sand and rocks for the design, represent a radical departure in the style of the *karesansui*. Shigemori designed the garden so that it could be used as a performance and exhibition space. An exhibition of metal sculptures, and a traditional dance produced by Shigemori himself, took place two years after the garden's completion, the first time a performance had been held in a Japanese stone garden.

LEFT The layout of this radically different *karesansui* resembles the foundation lines of the original castle.

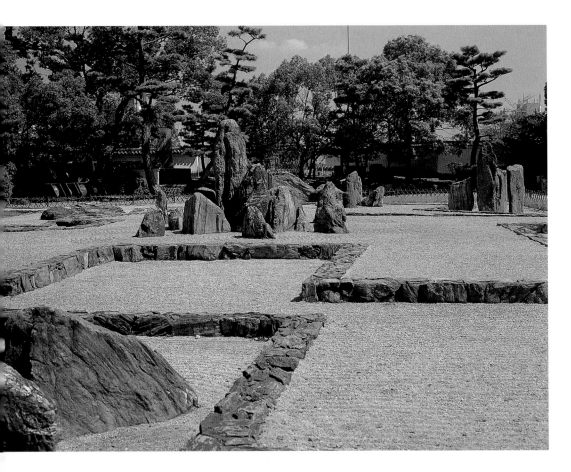

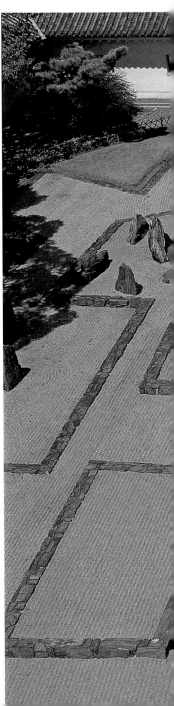

ABOVE The large central rocks represent the main battle camp of Zhuge Liang as it is depicted in a martial scene from Chinese mythology.

RIGHT The top floor of the castle tower commands a view of the garden, but also a chance to better understand the linear organization of the stones.

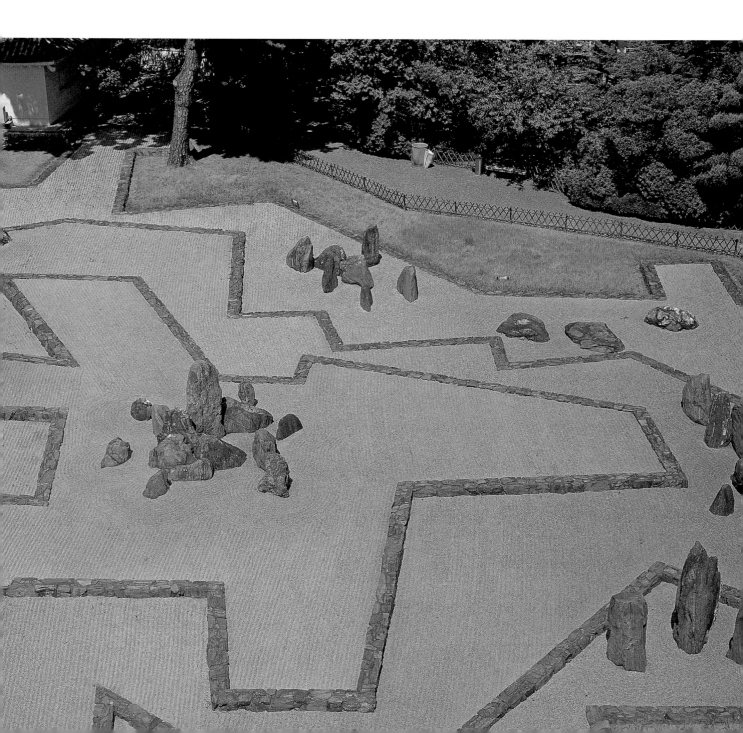

Raikyu-ji

Raikyu-ji, a temple garden in Bitchu Takahashi, is the work of Kobori Enshu, one of Japan's foremost designers of *karesansui*, and an advocate of the tea ceremony. To enter the temple, one ascends time-worn stone steps overgrown with tufts of grass, an indication that only a trickle of visitors disturb the tranquility of the setting despite the garden's age and cultural importance.

Enshu, a master in the placement of stone, gravel and rocks, completed the garden in 1609. The focus is an imposing stone triad forming a crane and turtle island, with a central standing rock, surrounded by well-pruned azalea bushes. Mount Atago is visible in the distance over more azaleas, forming the classic "borrowed view" frequently incorporated into such designs.

The garden has one of the most striking examples of *karikomi* (topiary) in Japan. Dense, tightly pruned azalea bushes descend from a containing bank of camellias, forming shapes that are said to resemble waves crashing onto the sea of white gravel, though others see billowing clouds in the curvaceous greenery.

The garden emphasizes harmony and spiritual peace in both the dynamics of the composition and the onlooker. Like all the most accomplished *karesansui*, the garden induces a dual response: an immediate sense of calm, a release from the world as we know it, superceded by a more reflective, pensive mood in which to appreciate this exquisite garden.

ABOVE Pebbles and paving stones beneath the temple eaves, which help to drain rain runoffs, were a later addition.

RIGHT Kobori Enshu's highly accomplished garden includes a crane and turtle island composition and a fine borrowed view of Mount Atago.

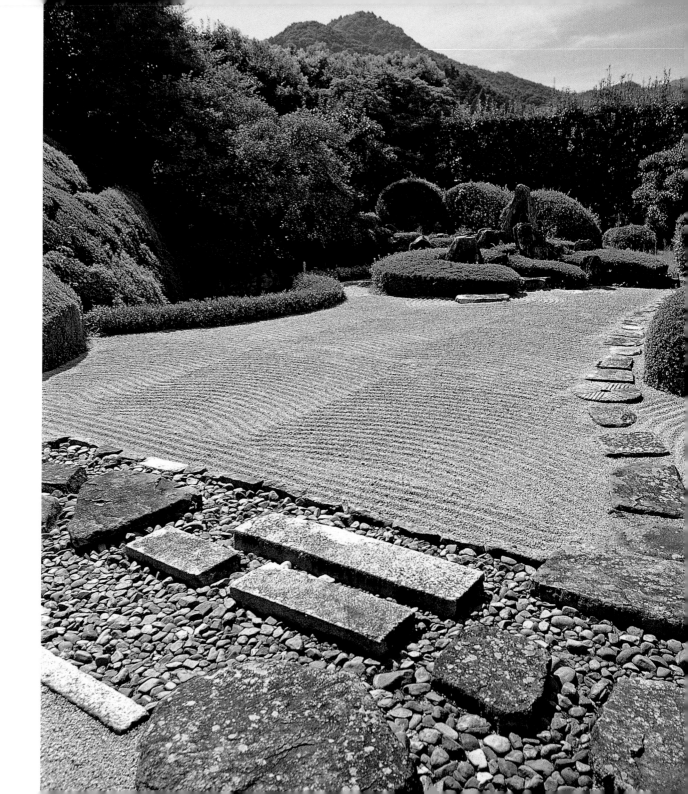

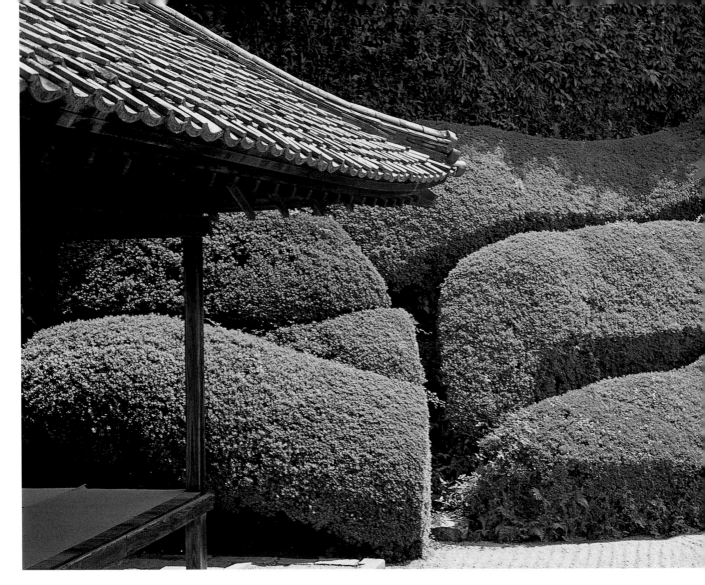

ABOVE Raikyu-ji has one of the most outstanding examples of topiary art in Japan.

RIGHT Hard but fluid stone lines are placed in contrast to sand ripples and undulating azalea bushes.

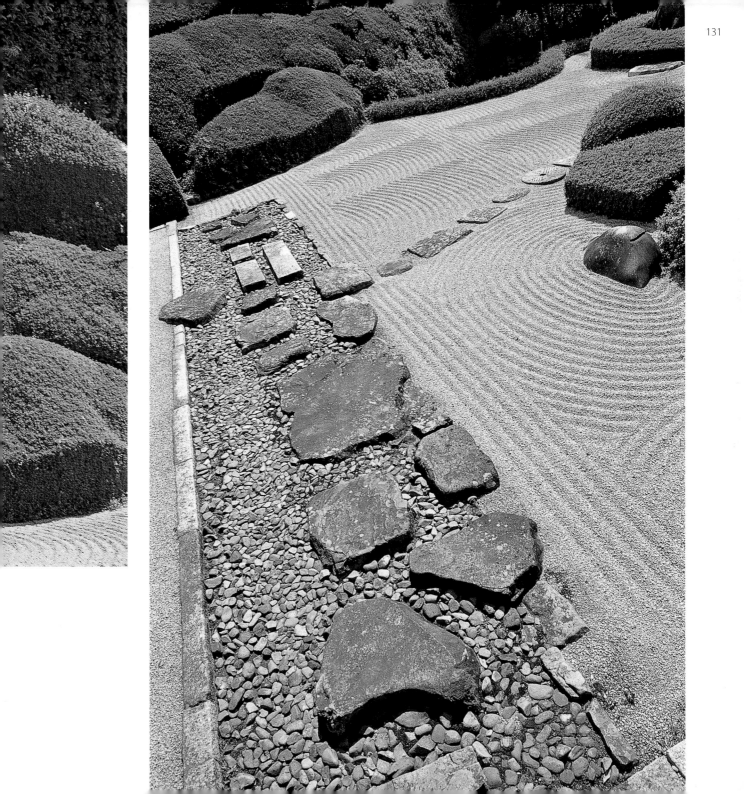

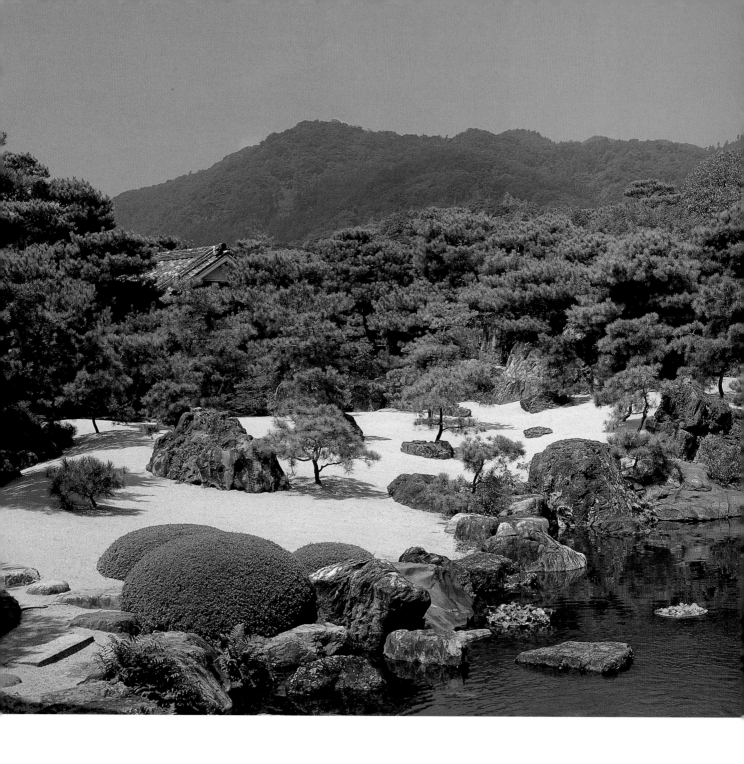

Adachi Museum

Some 20 kilometers from the prefectural capital of Matsue, the Adachi Museum is almost better known for its landscaped garden than its impressive collection of contemporary Japanese paintings and ceramics. Kinsaku Nakane completed the five hectacres of interconnecting gardens in 1970, a monumental task that must be considered a modern masterpiece.

The grounds consist of dry landscape, gravel and black pine, moss, water and tea gardens. The different elements are skillfully woven together to form a continuous landscape. The museum's corridors, wings, broad windows and open patios frame painterly landscapes as one proceeds through the galleries, each section of the meticulously tended grounds appearing from a different perspective. Zenko Adachi, the museum's founder, is quoted as saying, "The garden is, so to speak, a picture scroll," a fitting description of the horizontal panel-famed views visitors enjoy as they proceed through the building.

The award-winning garden is unusually rich in plantings of miniature trees, pines, bushes and undulating grass, which contrast with the dazzling white gravel. The most impressive of the garden's several borrowed views is a 15-meter-high waterfall cascading down a rock face. The waterfall appears to be entirely integrated into the garden grounds but actually lies beyond its boundaries and a road that is concealed from sight. Seven permanent gardeners maintain the manicured grounds, creating a landscape that almost seems too perfect. Nakane considered this to be the most important commission he had ever undertaken.

LEFT Kinsaku Nakane's highly ambitious design covers a staggering 43,000 square meters.

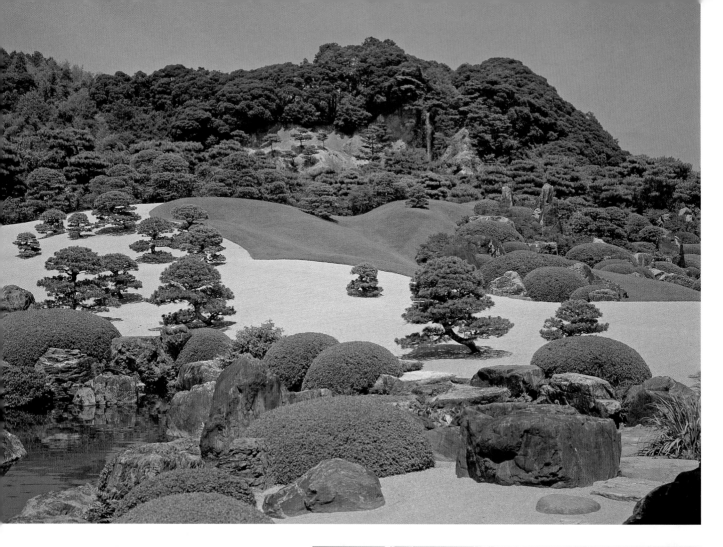

ABOVE Kinsaku Nakane skillfully co-opted background scenery into the garden, including a waterfall.

RIGHT The museum's founder, the late Zenko Adachi, described the design here by saying, "The garden is, so to speak, a picture scroll."

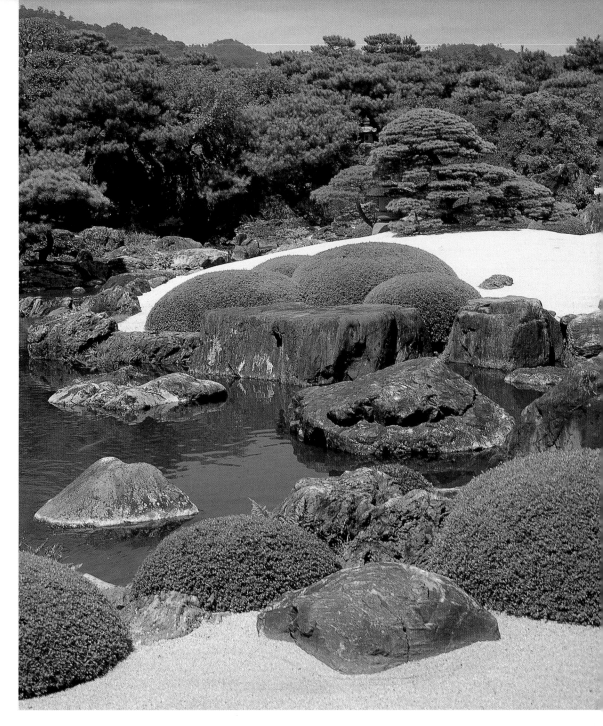

RIGHT Not strictly a *karesansui*, the garden incorporates large numbers of pine trees, manicured bushes and sloping lawns.

Senshukaku Pavilion

Built in 1590, the Senshukaku Pavilion garden was originally part of a *shoin*-style villa in the grounds of Tokushima Castle. Senshukaku, the name of the garden that has survived down the centuries, means Pavilion of a Thousand Autumns.

Now a park charging a small entrance fee, the grounds consist of a pond and mountain garden and a *karesansui*. Massive blue-gray colored rocks are liberally used throughout the garden as bridges, embankments, stepping stones and arrangements symbolizing Mount Horai. The presence of these very assertive rocks reflects the confidence of Momoyama period gardens and castle architecture. Contrasting with the hardness of stone are clumps of azalea, cherry, pine and giant cycads.

A 10.6-meter-long stone bridge in the dry landscape garden connects turtle and crane islands. It is believed to be the longest such garden feature in Japan. It is quite common to see visitors walking along the bridge. No one appears to object to the practice. The dry landscape section of the grounds exemplifies the idea contained in the ancient gardening manual, the *Sakutei-ki*, that "There should always be more horizontal than vertical stones" in a garden.

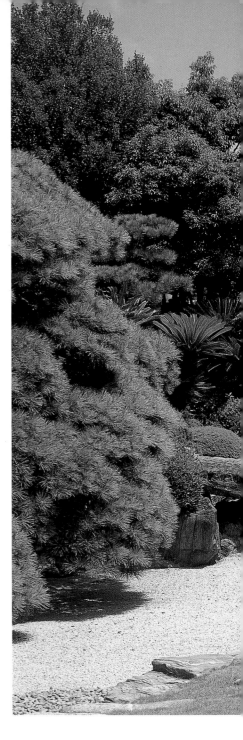

RIGHT Completed in 1592, the Senshukaku or Pavilion of a Thousand Autumns received its poetic name only in 1908.

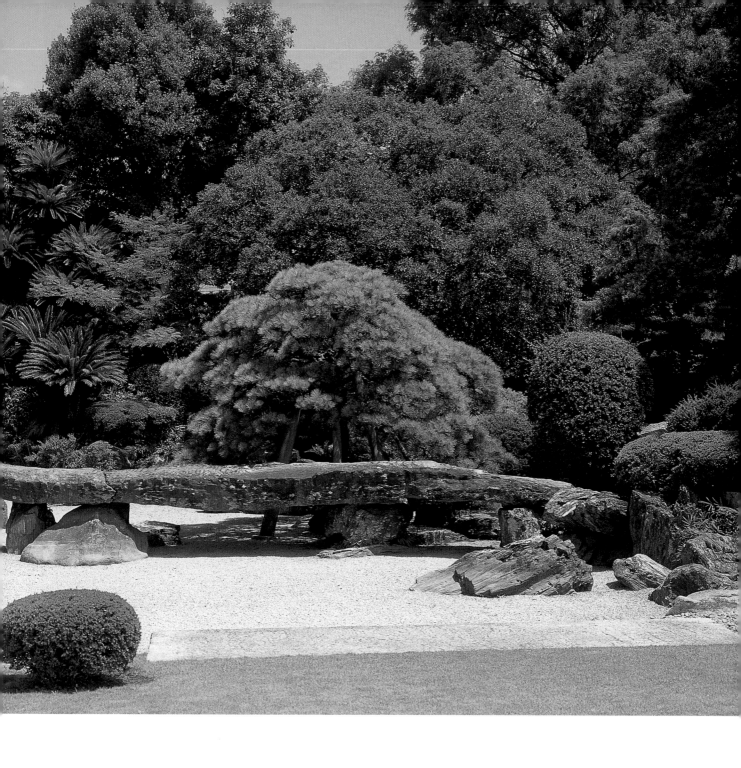

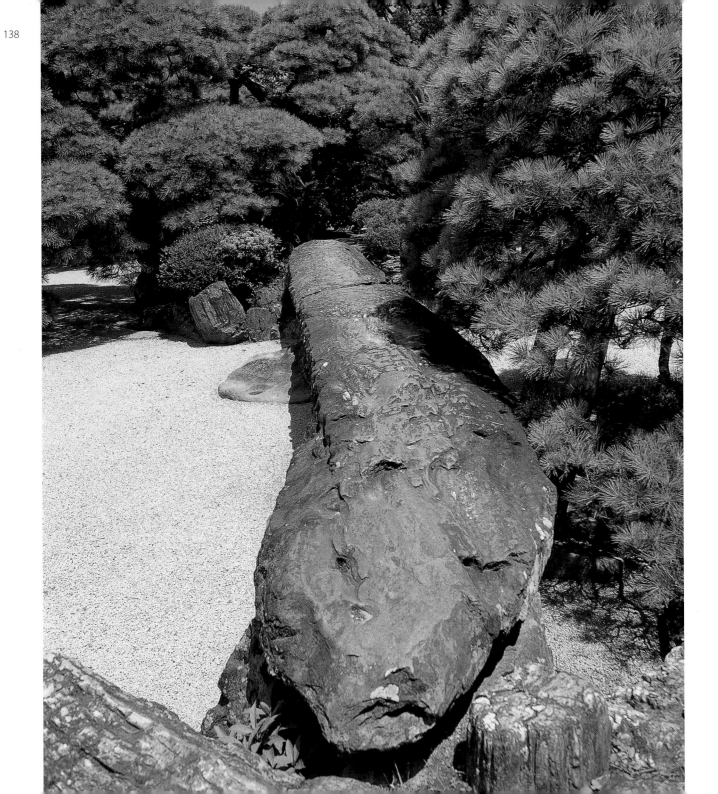

LEFT The roughly 10-meter-long stone bridge connects the crane and turtle island groups in the garden.

RIGHT Pines and azaleas soften the highly assertive rock elements in this garden.

BELOW Besides azaleas and pine, huge cycads are planted in the *karesansui*, adding a subtropical appearance to parts of the garden.

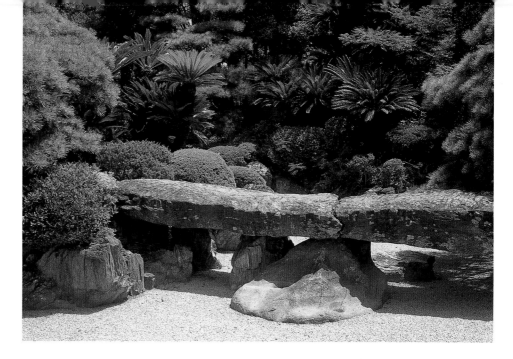

Joei-ji

The Joei-ji garden in the provincial city of Yamaguchi, also known as the Sesshu-tei, occupies part of a villa once owned by Masahiro Ouchi, head of a powerful local clan. It was converted into a temple, the Joei-ji, in 1455.

Returning on an Ouchi trading ship from China where he had gone to study the arts, the painter Sesshu was asked to design a traditional Japanese garden for the temple. Apparently, there was no contradiction seen in the idea of a painter also being a landscape designer. As Donald Richie has written of the era, "Painters painted landscapes and the gardens of the period were by definition landscapes."

The result, an arrangement of stones, rocks, lawn and lily pond, is best viewed in its intended entirety from the broad wooden verandah at the rear of the temple. Paths run on four sides of a central arrangement: one beneath the viewing verandah, the other rising up into woodland that both masks off and reveals the design from differing angles.

Rocks are arranged into small groups and triads, bordered by low bushes, many of the arrangements representing Chinese mountains of special note. One particular rock and bush composition, in the shape of an inverted fan, clearly represents Mount Fuji. Turtle and crane islets and a dry waterfall descending a small gully are other stone forms found in this varied garden.

The Joei-ji garden is Sesshu's earliest known work. Still a young man at the time, the design nonetheless represents an extremely mature surety of line and composition, as if the garden were a three-dimensional extension of his own ink paintings. Orientalist Ernest Fenollosa wrote of Sesshu, "He is the greatest master of the straight line and angle in the whole range of the world's art."

Although the garden attempts to concentrate the mind by removing the distraction of too much color, it is lush and green in summer with yellow lilies in its pond, creating the impression more of a paradise garden than a dry landscape one.

RIGHT Combining a "dry" and "wet" garden, the pond beyond the *karesansui* has been built in the shape of the Chinese ideogram for "heart."

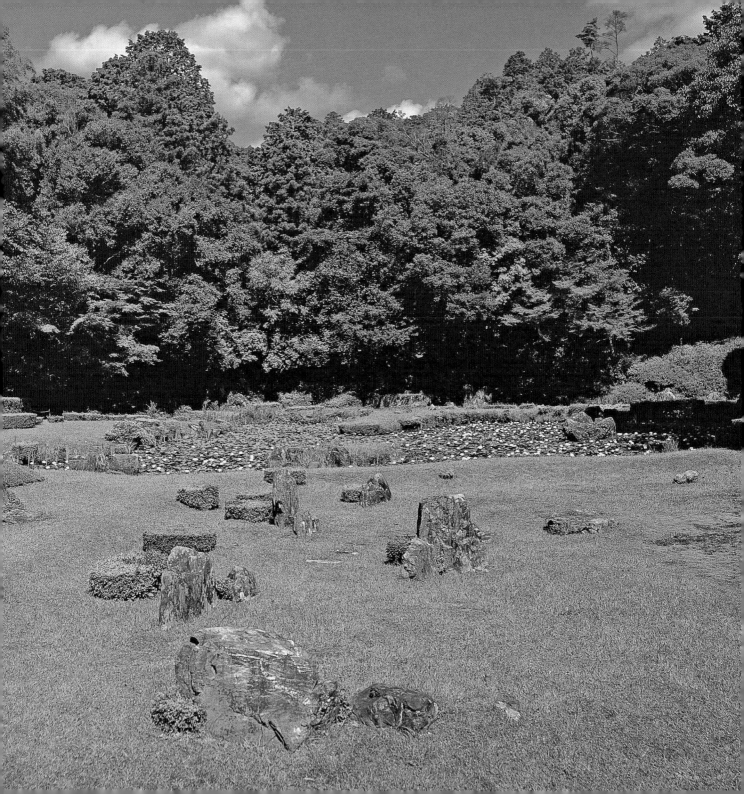

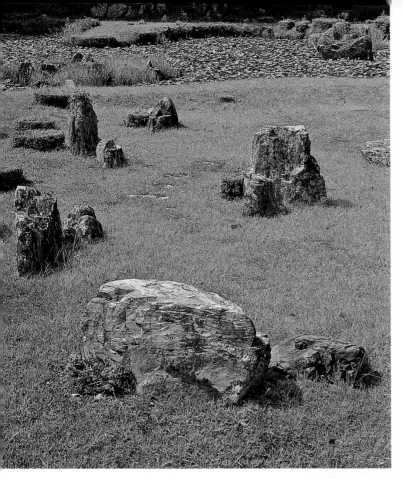

ABOVE The rock groupings create three-dimensional realizations of Sesshu's own paintings.

RIGHT A surprising degree of angularity, achieved with straight lines and flat-topped rocks, define both Sesshu's art works and his garden designs.

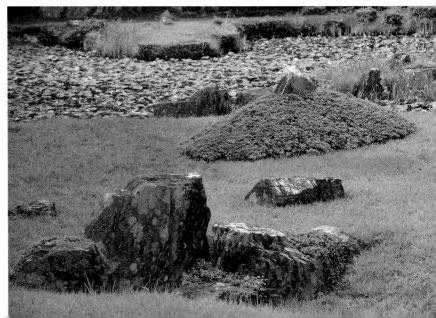

ABOVE The clipped hedge and stone peak of the form at the rear bear an unmistakable, and intentional, resemblance to Mount Fuji.

RIGHT Divided into two sections crossed by an earthen bridge, the pond contains an island in the shape of a boat, a rock island, and a crane and turtle island.

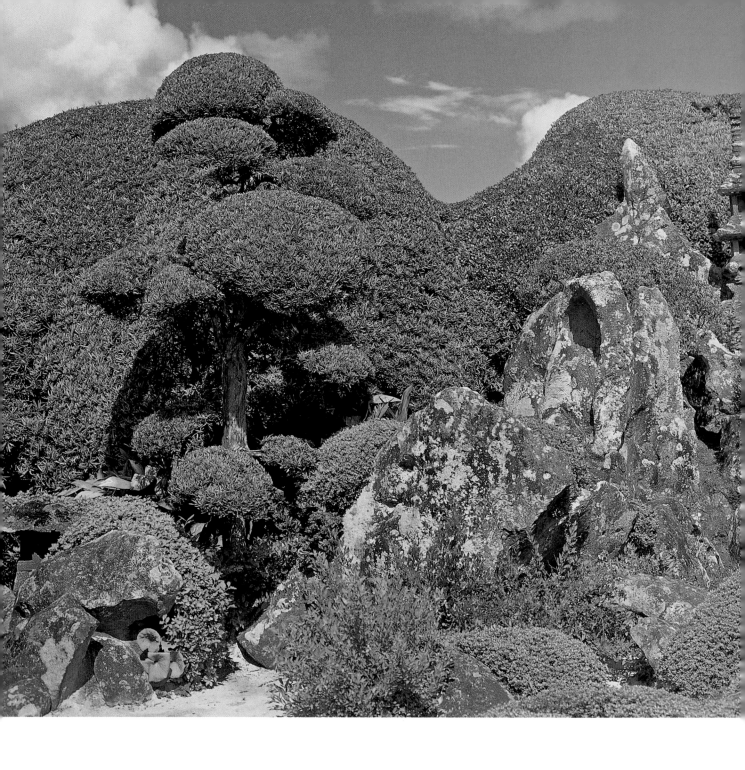

Chiran Gardens

To enter the gardens at Chiran, a subtropical town of tea plantations, old wooden samurai villas, volcanic hills and shallow valleys on the southernmost tip of Okinawa is to enjoy a world of small refinements.

In reward for their good services, Chiran's rulers were promoted to membership of the samurai class. Travelling to Kyoto, they were able to view some of the country's finest examples of garden design. On their return home, they hired gardeners to create landscapes that would match the natural surroundings of their own village.

All seven of the miniature Edo period gardens at Chiran share the common feature of having borrowed scenery, with mountains, forests, hills, tiled roofs, even the top of a stone lantern, co-opted as part of the garden. Each garden is named after the head of the family who lived in the house.

The Keiichiro Saigo garden looks simple, most of its landscaping in one corner of the yard in front of the house. On closer examination, however, one can see how complex it is. Rocks are carefully angled, plants and miniature trees are beautifully arranged. The garden evolves into something like the landscape of a Chinese ink-wash painting. A few steps across the lane is the peaceful Katumi Hirayama garden, with its old lanterns and Buddhist stones.

In the Ryoichi Hirayama garden, rocks are completely absent. Instead, a wide area of azalea shrubbery represents mountains. The contrast between the different shades of green in the color of the azaleas, the hedge and the emerald hills on the horizon, is a very effective technique. The tops of hedges have been clipped into angles to match the outline of the hills.

LEFT Mottled rocks, stone lanterns, azaleas, topiary and a stone pagoda add interest to the Keiichiro Saigo garden, a work of skillful compression.

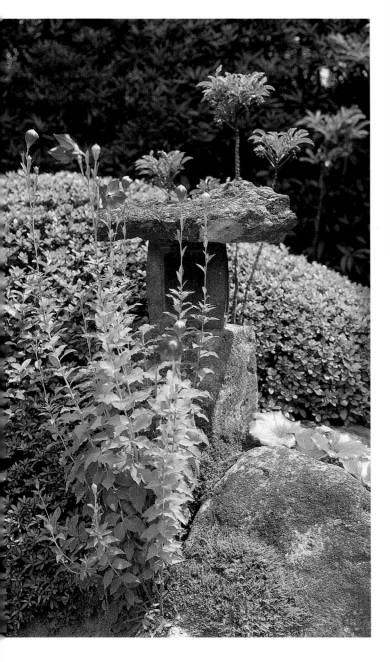

LEFT Japanese bellflowers blooming in one of Chiran's Edo period gardens.

ABOVE The stone walls of the samurai residences at Chiran are composed with the same precision as the gardens.

RIGHT A wonderfully massed and contoured area of topiary, suggestive of the undulating hills that surround Chiran.

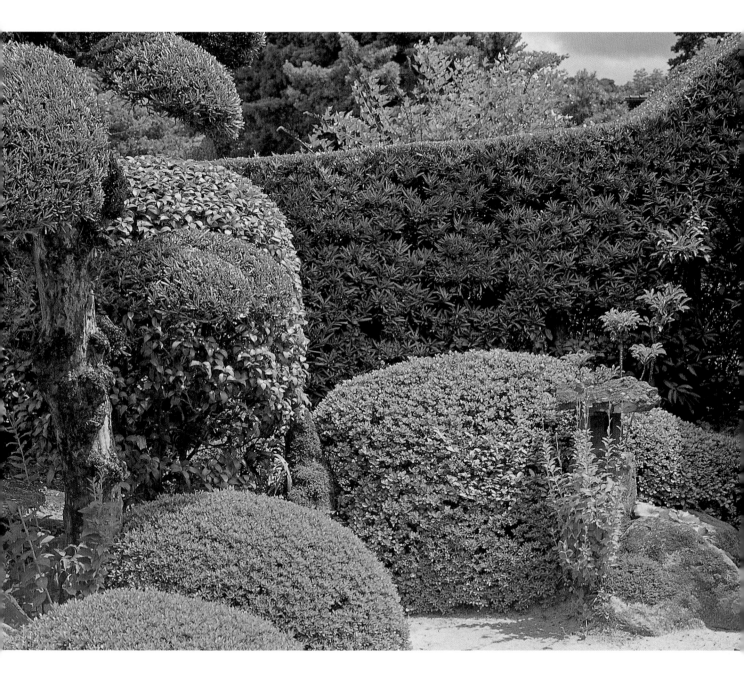

Canadian Embassy

Completed in 1991, the stone garden at the Canadian Embassy in the Aoyama district of Tokyo is the work of the landscape designer Shunmyo Masuno. A Zen priest, writer and garden theorist, Masuno was eminently qualified to undertake a work aimed at symbolizing the friendship between Canada and Japan.

Constructed across the wide, eastern-facing upper terrace of the embassy, the Canada Garden uses a number of large, irregular stones to evoke the immense landscape and geology of the Canadian Shield. Roughly cut to suggest the ruggedness of the terrain, lines of wedge holes have been left deliberately untouched. The massive weight of the granite stones posed structural problems for the terrace. This was solved by painstakingly hollowing out the rocks. The far end of the garden turns a sharp angle at an *inukshuk*, a symbolic marker used by the Inuit people of Canada's Arctic region. Three pyramid-shaped blocks at the nearby northern edge of the garden represent the Rocky Mountains.

Overhanging the main garden and compressing the landscape into a framed panorama is the projecting roof of the embassy. Geometrically precise floor tiles link the main building with the rock arrangement, ensuring that the stark monochrome elements of the garden complement the concrete and glass of the modern building.

A truly modern garden, it also adheres to traditional garden methods. The tree lines of the Takahashi Memorial Gardens to the immediate east and the tree tops of the Akasaka Palace to the north and northeast are incorporated into the garden in the manner of Edo period borrowed scenery.

RIGHT In accord with the idea of a Canadian geological landscape torn apart by glaciers, Shunmyo Masuno's stonemason has left the rocks as they were when they split.

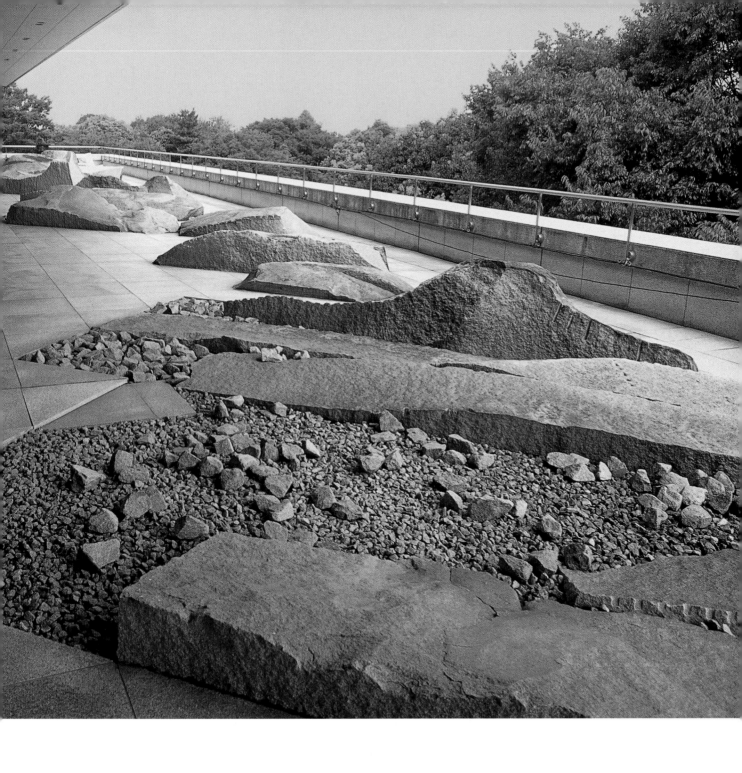

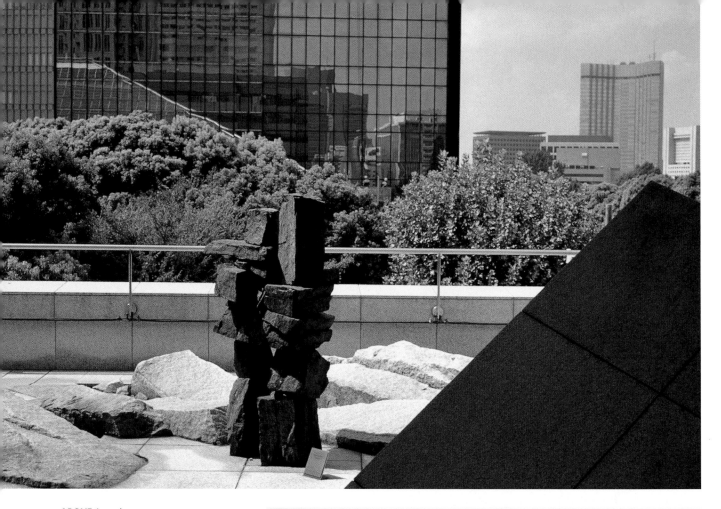

ABOVE A marker stone or *inukshuk*, a symbol of the Inuit people of the Canadian Arctic, stands at the corner of the garden.

RIGHT Paving stones, cut rock, loose stone and gravel create a surprising harmony of form.

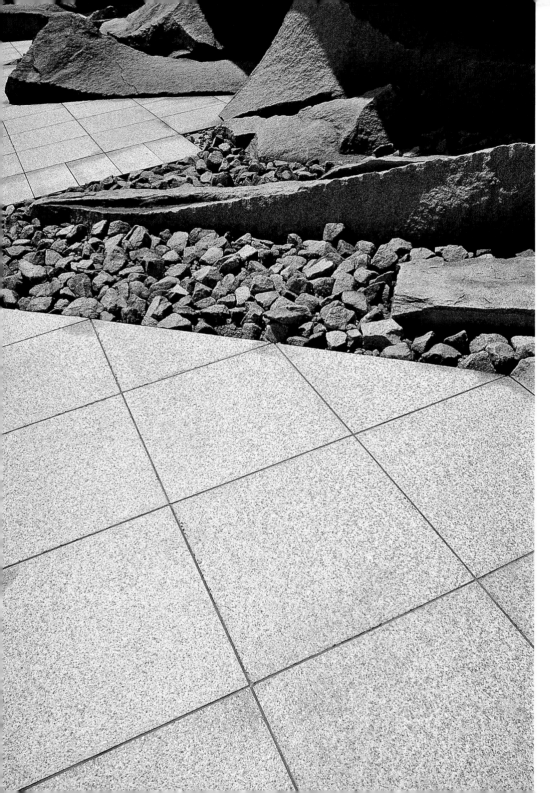

LEFT AND ABOVE Large slabs of granite were transported onto the reinforced upper-level terrace of the embassy's fourth floor during the five years it took to complete the garden. Because of their weight, the stones had to be first carefully hollowed out.

LEFT Okinawan gardens reflect climatic and horticultural differences, but also disparities in taste and cultural preferences.

Miyara Dunchi

The world's first gardens may well have been made of coral, natural clusters of underwater beauty that could be glimpsed through the glass of the water. Perfectly tone and color coordinated and formed, they were refined to a degree that may have suggested the presence of the divine. Those living in the coral islands of Okinawa have been well placed to observe these marine gardens, learn from them and requisition their treasures.

Ishigaki Island's Miyara Dunchi, located down one of the lanes of the old quarter of the port town, is a samurai-style villa. Built in 1819 by the magistrate for the Yaeyamas, Miyara Peichin Toen, it is the oldest surviving such building in Okinawa. The worn, salt-encrusted wood along the verandah looks out onto a dry landscape arrangement that seems to owe more to China than Japan.

A fondness for stones, the sharp, spiny rocks of their own coral islands, so different from the smooth, moss-covered variety found in Japanese gardens elsewhere, typifies this and many other Okinawan gardens. If rocks represent mountains, in Okinawa they also evoke coastal cliffs and offshore formations. Never far from the sea, these stone arrangements are doubtless modified versions of the complex, interlocking rock piles, full of scooped surfaces and cavities, found in classic Chinese gardens. The variegated greens of the garden, seen in clumps of aspidistra and large, healthy-looking cycads, are complemented by the red and yellow flowers of hibiscus, creating a truly Okinawan garden flavor.

BELOW Aesthetically pleasing within their very different subtropical island settings, Okinawan walls like this one on the neighboring island of Taketomi-jima are living structures.

RIGHT Smaller stones and plants such as aspidistra, that do well in the subtropics, differentiate Okinawan gardens from their mainland counterparts.

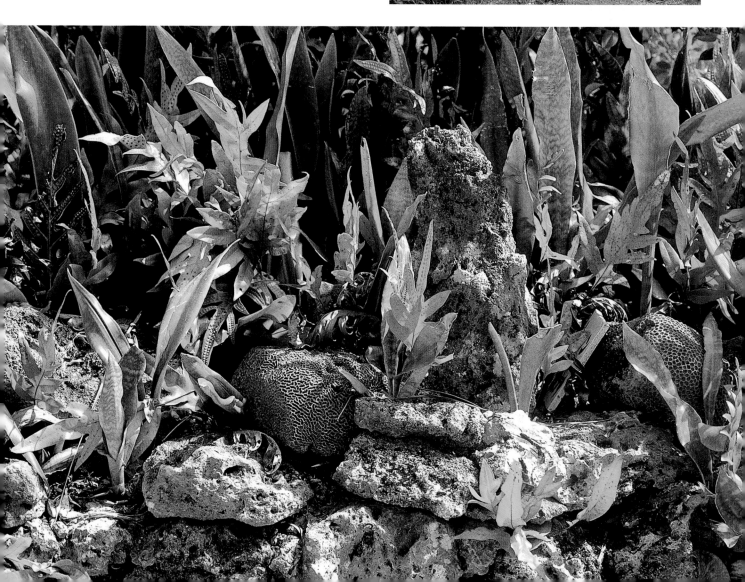

ABOVE The variegated greens seen in clumps of aspidistra and large, healthy-looking cycads blend with coral rocks suggestive of Chinese gardens, with their fabulist piles of energizing stones full of blowholes, scooped surfaces, cavities and hollows.

GLOSSARY

ao ishi a blue-green chlorite schist

bonseki stones suggesting natural settings displayed on a dry tray

chozubachi a water laver

gohei sacred paper streamers

hensei-gan metamorphic rocks with an extremely hard texture

hinbon seki a horizontally arranged triad of rocks

hira-niwa the flat garden style common to stone gardens

hojo the abbot's quarters in a temple complex

inu-bashiri narrow strips of small stones running between a wall and garden

ishi-tate-so priests trained in the art of setting stones

ishi wo taten koto the art of setting stones.

ishi usu flat-surfaced millstones

iwakura rocks worshipped as deities

iwasaka divine boundaries

kami the Shinto gods

kasei-gan rough igneous rocks

kekkai "border zones" marking the boundaries between the human and sacred

kiyome-no-mori two cones of sand in the forecourt of Shinto shrines, denoting purity

kansho niwa a contemplation garden

karesansui a dry landscape garden

karikomi topiary art

kirishi cut rocks

masago granite that becomes grainy sand

mikage ishi granite

mitate-mono recycled or requisitioned items for garden use

miyabi grace and refinement

mu nothingness

mujo the idea of impermanace, connected to the Buddhist concept of *ukiyo*, the "floating world"

mutei the most simple and minimalist of stone gardens, literally "garden of emptiness"

nachiguro black pebbles sometimes used at the edges of gardens

nantei a sand-covered courtyard positioned south of the *shinden* villas

neribei clay walls

niwa a term used to denote gardens in general

ryu-mon-baku a "dragon's-gate-waterfall" made from rocks rather than actual water

Sakutei-ki an important eleventh-century gardening manual

sanzonseki a cluster of three rocks representing Mount Sumeru or Mount Horai

sensui kawaramono outcasts who lived on the banks of rivers, some of whom became skillful gardeners

shakkei "borrowed view" incorporated into a garden

shiki no himorogi sacred precincts set aside for ritual purifications

shime-nawa sacred rope

shinden Chinese-inspired symmetrically arranged residences of the nobility

shinden-zukuri an architectural style associated with Heian period palaces

Shinto Japan's native animist-based religion

shira-kawa-suna sand taken from the Shirakawa River

shishin soo ancient site-determining concept based on the belief that designated areas are under the protection of four gods

shoin the abbot's study adjacent to the garden

shoin-zukuri a Zen temple design post-dating the *shinden-zukuri*

shomoji a low social class of sutra readers, whose services were also required as palace manual gardeners

Shumisen a sacred mountain at the center of the Buddhist cosmos

suisei-gan smooth, water-worn sedimentary rocks

suiseki miniature stones placed in watered trays to evoke landscapes

suteishi nameless or discarded rocks randomly placed to give the impression of spontaneity

teien a formal Japanese garden

tsuboniwa a courtyard garden

tsukubai a stone water basin

wabi-sabi the beauty of old and time-worn things

yohaku-no-bi aesthetic describing the beauty of empty but expressive space

yuniwa designated sacred plots

BIBLIOGRAPHY

Berthier, Francoise, *Reading Zen in the Rocks: The Japanese Dry Landscape Garden*, University of Chicago Press, Chicago, 2000.

Borja, Erik, and Paul Maurer, *Zen Gardens*, Seven Dials, London, 1999.

Cali, Joseph, *The New Zen Garden: Designing Quiet Spaces*, Kodansha International, Tokyo, 2004.

Carver, Norma, *Form and Space in Japanese Architecture and Gardens*, Documan, Kalamazoo, Maryland, 1991.

Cho Wang, Joseph, *The Chinese Garden*, Oxford University Press, Hong Kong, 1998.

Conder, Josiah, *Landscape Gardening in Japan*, Kodansha International, Tokyo, 2002 (1893).

Covello, Vincent T., and Yuji Yoshimura, *The Japanese Art of Stone Appreciation: Suiseki And Its Use With Bonsai*, Tuttle Publishing, Tokyo, 1984.

Earle, Joe, *Infinite Spaces: The Art and Wisdom of the Japanese Garden*, Tuttle Publishing, Tokyo, 2000.

Einarsen, John, *Zen And Kyoto*, Uniplan Co. Ltd, Kyoto, 2004.

Engel, David H., *A Thousand Mountains, A Million Hills: Creating The Rock Work of Japanese Gardens*, Shufunotomo Co. Ltd, Tokyo, 1994.

Harte, Sunniva, *Zen Gardening*, Pavilion Books Ltd, London, 1999.

Inaji, Toshiro, *The Garden As Architecture: Form and Spirit in the Gardens of Japan, China, and Korea*, Kodansha International, 1998.

Itoh, Teiji, *The Gardens of Japan*, Kodansha International, Tokyo, 1984.

Keane, Marc P., *Japanese Garden Design*, Tuttle Publishing, Tokyo, 1996.

Keane, Marc P., *The Art of Setting Stones and Other Writings from the Japanese Garden*, Stone Bridge Press, Berkeley, California, 2002.

Klingsick, Judith D., *A Japanese Garden Journey: Through Ancient Stones and Dragon Bones*, Stemmer House Publishers, 1999.

Koren, Leonard, *Gardens of Gravel and Sand*, Stone Bridge Press, Berkeley, California, 2000.

Kuck, Lorraine, *The World of the Japanese Garden: From Chinese Origins to Modern Landscape Art*, Weatherhill, New York, 1984.

Kuitert, Wybe, *Themes in the History of Japanese Garden Art*, University of Hawaii Press, Honolulu, 2000.

Main, Alison, and Newell Platten, *The Lure of the Japanese Garden*, Wakefield Press, Kent Town, 2002.

Mizobuchi, Hiroshi, *Shigemori Mirei, Creator of Spiritual Spaces*, Kyoto Tsushinsha Press, Kyoto, 2007.

Mizuno, Katsuhiko, *Gardens in Kyoto*, Suiko Books, Kyoto, 2002.

Moore, Abd al-Hayy, *Zen Rock Gardening*, Running Press, Philadelphia, 1992.

Nitschke, Gunter, *Japanese Gardens*, Taschen, Cologne, 1999.

Nose, Michiko Rico, and Mitchell Beazley, *The Modern Japanese Garden*, Octopus Publishing Group Ltd, London, 2002.

Richie, Donald, "Ryoan-ji: Notes for a Poem on the Stone Garden," from *Partial Views: Essays on Contemporary Japan*, The Japan Times Ltd, 1995.

Shunmyo, Masuno, *Inside Japanese Gardens: From Basics to Planning, Management and Improvement*, The Commemorative Foundation for the International Garden and Greenery Exposition, Osaka, 2003.

Slawson, David A., *Secret Teachings in the Art of Japanese Gardens*, Kodansha International, Tokyo, 1987.

Tachihara, Masaaki, *Wind And Stone*, Stone Bridge Press, Berkeley, California, 1992.

Takei, Jiro, and Marc P. Keane, *Sakuteiki: Visions of the Japanese Garden: A Modern Translation of Japan's Gardening Classic*, Tuttle Publishing, Tokyo, 2001.

Treib, Marc, and Ron Herman, *A Guide to The Gardens of Kyoto*, Kodansha International, 2003.

Tschumi, Christian, *Mirei Shigemori: Modernizing the Japanese Garden*, Stone Bridge Press, Berkeley, California, 2005.

Watts, Alan, *The Way of Zen*, Vintage Books, New York, 1957.

Wright, Tom, and Katsuhiko Mizuno, *Zen Gardens: Kyoto's Nature Enclosed*, Suiko Books, Kyoto, 1990.

Yamamoto, Kenzo, *Kyoto Gardens*, Suiko Books, Kyoto, 1995.

Yoshikawa, Isao, *The World of Zen Gardens*, Graphic-za, Tokyo, 1991.

Young, David, and Michiko Young, *The Art of the Japanese Garden*, Tuttle Publishing, Tokyo, 2005.

ACKNOWLEDGMENTS

Thanks are firstly due to Japan's legions of professional gardeners who lovingly maintain this precious heritage. Priests and monks at certain temples, called upon to perform much the same task, also act as the historical curators of these gardens. Although I did not always have the chance to witness them at work, I would like to express my gratitude to those I did meet and to their infinite patience in answering my queries.

My thanks also go to the staff of several Tokyo libraries, especially the Japan Foundation Library in Yotsuya. All the writers mentioned in the Bibliography have provided excellent models for book composition and, in some instances, introduced me to little-known gardens. If I had to single out for praise one book in particular, it would be Marc Peter Keene's beautifully written and inspiring *The Art of Setting Stones*.

While my book could be considered an illustrated guide to stone gardens, its emphasis on basic principals and design concepts is intended to expand the viewer's perspective and deepen an understanding and appreciation of these enduring works of art.

Last but not least, I am indebted to the editing and design team at Tuttle for their innovative suggestions and willingness, on occasions, to defer to my own judgment. As books like this should be, it was a true collaboration.

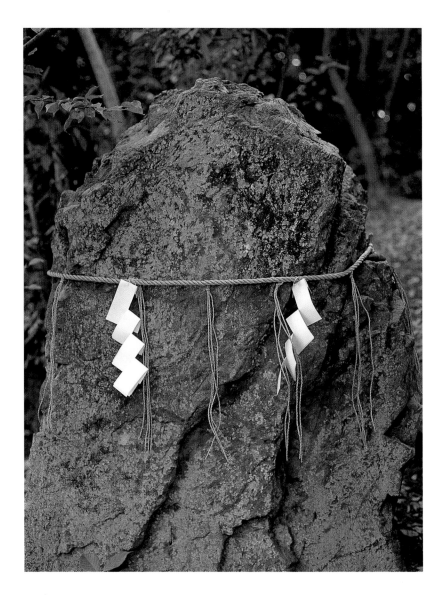

ABOVE Worshipped for the presence of deities, sacred *iwakura* rocks like this one at Achi Shrine in Kurashiki, predate even Japan's native Shinto religion.

INDEX